Sixties Fashion

Modefotografie & -illustration
Fashion Photography & Illustration

Verlag der Buchhandlung Walther König

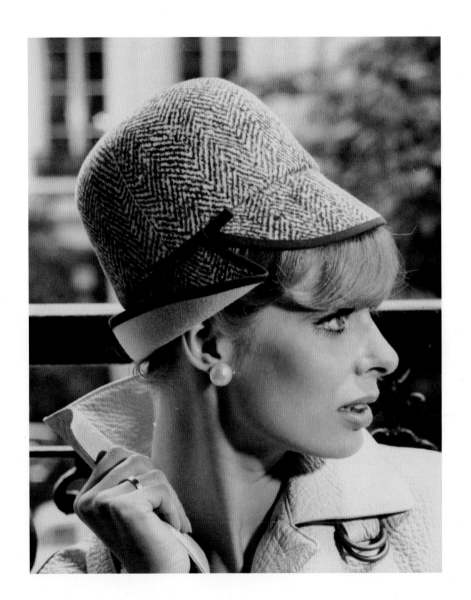

Sixties Fashion

...ografie & -illustration
Fashion Photography & Illustration

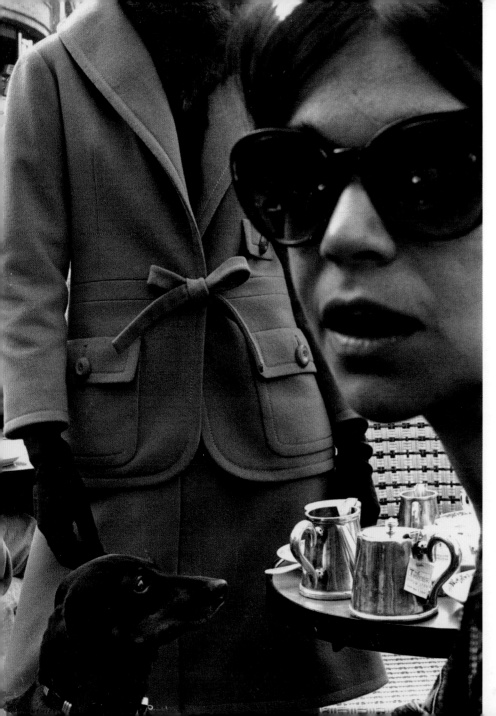

Für die / for the Kunstbibliothek Staatliche Museen zu Berlin herausgegeben von / Edited by Adelheid Rasche mit Beiträgen von / with contributions by Adelheid Rasche und Hildegard Ringena

S M
B Kunstbibliothek
 Staatliche Museen
 zu Berlin

Sammlung Modebild – Lipperheidesche Kostümbibliothek

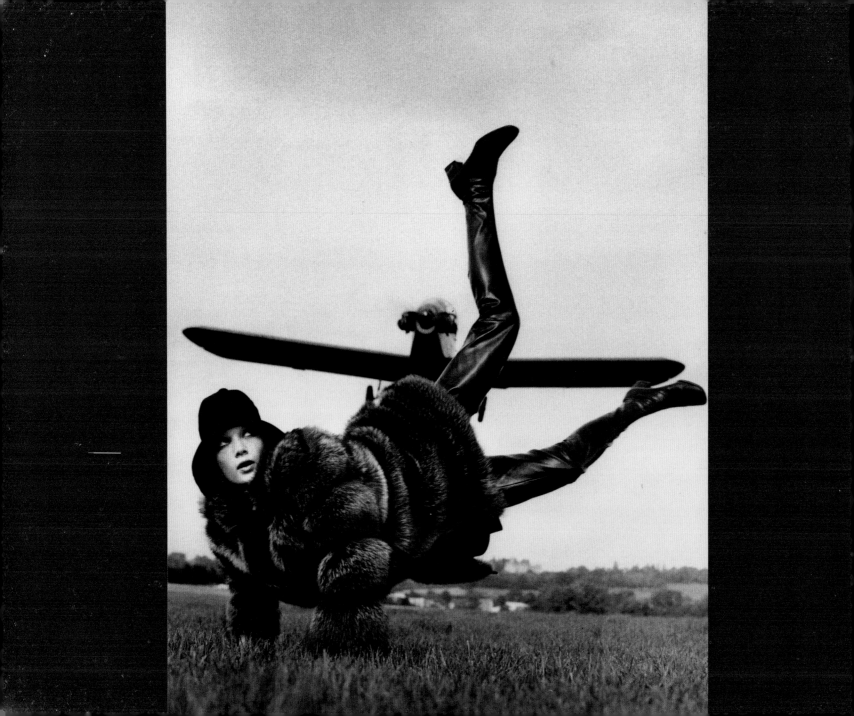

Das 20. Jahrhundert war das erste und vielleicht das letzte Jahrhundert, das sich nach Dekaden sortierte. Kein Mensch wäre im 19. Jahrhundert auf die Idee gekommen, von den „spießigen Fünfzigern" oder den „roaring twenties" zu reden. Noch nie gab es soviel Kult um das Jahrzehnt. Von einem bloßen Zeitintervall wandelte es sich zum nostalgischen Erlebnisraum mit brauchtümlichen Sets von musikalischen Evergreens, Moden, Accessoires, „unvergessenen" Stars und „unsterblichen" Legenden.

Bis heute haben diese Jahrzehnte nichts von ihrer Faszination verloren, immer wieder werden sie neu rekombiniert. Zugkräftigster Motor dieser Recycling-Prozesse ist die Mode. Manche ihrer ‚remakes' sind so linientreu, dass perfekte ‚fakes' entstehen. Sie machen es möglich, dass mancher für Jahrzehnte im Gewand ein und desselben Jahrzehnts lebt. Prominente Beispiele sind Max Raabe und die Zwanziger, Götz Alsmann und die Fünfziger oder – in einer ungleichen Balance von Geschmack und Beharrungsvermögen – Thomas Gottschalk und die Achtziger. Meist sind die Variationen jedoch spielerisch und frei. Man denke etwa an das Sechziger-Revival Mitte der 1990er Jahre, als Wigald Boning mit der Neukombination von „Humana"-Klamotten zum Trend-Setter wurde, oder an die Achtziger-Renaissance unserer Tage. Letztere ist ein besonders komplexer Fall, denn die Achtziger hatten ja ihrerseits die Fünfziger entdeckt.

In diesem Recycling-Labyrinth verliert selbst der Mode-Experte schnell das Original aus den Augen. Die Jahrzehnte werden von ihren Kopien überlagert. Mythen treten an die Stelle der Geschichte. Umso wichtiger ist die Sicherung und Erforschung der authentischen Quellen. Die Kunstbibliothek mit ihren reichen Sammlungen zur Geschichte des Modebilds bietet dafür ideale Voraussetzungen. Seit Jahren setzen die Ausstellungen und Publikationen unserer Modekuratorin Adelheid Rasche Standards für die Forschung. Nach Ausstellungen zu den „Fifties" bei Christian Dior (2007) und zur Mode der 1920er Jahre (2009) rücken nun die „Sixties" in den Fokus. Wieder einmal geht es um den mythenfreien Durchblick auf ein Modejahrzehnt in höchstmöglicher Auflösung. Der Titel ist Programm: „High Sixties Fashion".

Moritz Wullen
Direktor Kunstbibliothek

The 20th century was the first and perhaps the last century to arrange itself according to decades. In the 19th century, no one would have thought of talking of the 'conservative Fifties' or the 'roaring Twenties'. Never before had there been so much cult surrounding the decade. 'The decade' changed its meaning – from a mere period in time to a nostalgic space of experience with custom sets of golden oldies, fashions, accessories, 'unforgotten' stars and 'immortal' legends.

The decades of the 20th century have lost none of their fascination even to the present day; they are revisited and adapted time and again. The strongest motor for these recycling processes is fashion. Some of its 'remakes' are so true to the original that perfect 'fakes' are created as a result, allowing some people to spend decade after decade in the outfit of one and the same decade. Well-known examples are Max Raabe and the 1920s, Götz Alsmann and the 1950s, or – in a questionable balance of taste and sheer tenacity – Thomas Gottschalk and the 1980s. For the most part, however, variations in styles are playful and free. Think of the Sixties Revival in the mid-1990s, when Wigald Boning became a trendsetter with his new combination of second hand gear, or the Eighties revival of recent years. The latter is an especially complex case as, at the time, the Eighties themselves marked the partial rediscovery of the Fifties.

In this maze of recycling, even fashion experts can easily lose sight of the original. The decades are superimposed by their copies. History is replaced by myths. It is all the more important then that authentic sources are preserved and studied. The Art Library, with its rich collections on the history of fashion, offers ideal conditions for this. The exhibitions and publications of our fashion curator Adelheid Rasche have been setting academic standards for years. After exhibitions on Christian Dior and the Fifties (2007) as well as on Twenties fashion (2009), this year sees the Sixties brought into focus. Once again, the aim is to create a demythologized picture of a decade of fashion, in as high a resolution as possible. The title thereby also sets our agenda: 'High Sixties Fashion'.

Moritz Wullen
Director of the Art Library

Sixties Fashion

Markante Modeumbrüche und auffälliger Silhouettenwandel reflektieren in besonderem Maße die sozialen, gesellschaftlichen und kulturellen Entwicklungen einer Epoche. In kaum einem Zeitraum lässt sich dies deutlicher beobachten als in den sogenannten „langen 1960er Jahren", die von der historischen Forschung auf die Jahre 1958 bis 1973/74 datiert wurden.

In bewusster Konzentration liegt der Fokus dieser Publikation auf den wichtigsten Modephänomenen der „High Sixties" (1964–1969), aufgezeigt an internationalen Modefotografien und -illustrationen aus den Sammlungsbeständen der Sammlung Modebild – Lipperheidesche Kostümbibliothek (Kunstbibliothek Staatliche Museen zu Berlin). In dieser weltgrößten Fachsammlung und Bibliothek zur Kulturgeschichte von Kleidung und Mode konnte in den letzten Jahren durch umfangreiche Schenkungen und einige Ankäufe insbesondere die mediale Präsenz der Mode der 1960er Jahre verstärkt werden; hervorgehoben seien die umfangreiche Schenkung der Berliner Zeitung *Der Tagesspiegel* mit internationaler Modefotografie, der breit gefächerte Nachlass des Modejournalisten Carl-Heinz Bauer sowie die durch Spendenmittel von MaxMara srl ermöglichte Erwerbung von drei Modezeichnungen des namhaften Illustrators Antonio. Ergänzend zu den originalen Fotografien und Illustrationen sind in dieser Publikation einige Bildseiten aus Modejournalen zu sehen, die Bilder weiterer bedeutender Fotografen wie Richard Avedon oder Hiro vorstellen.

Einflüsse und Entwicklungen

Zum Ende der 1950er Jahre, die durch die damenhaft-eleganten Kollektionen der Pariser Haute Couture von Dior, Chanel, Balenciaga und anderen Modeschöpfern geprägt waren, kündigten sich bereits deutliche Zeichen eines Umbruchs an. Insbesondere in den Vereinigten Staaten von Amerika, aber auch in Europa war eine junge kaufkräftige Generation herangewachsen, die mit den Modeidealen ihrer Eltern nicht mehr konform ging. Der Einfluss der Teenager und Studenten äußerte sich in allen Lebensbereichen, in Politik, Wirtschaft und Kultur. Gerade das Zusammenspiel von wirtschaftlicher Stabilität, sozialem Engagement und Erblühen der Populärkultur sowie des Massenkonsums sollte für die Modeentwicklung der 1960er Jahre entscheidend werden.

Sixties Fashion

To a large extent, striking changes in fashion and a noticeable change in silhouette are a reflection of the social, societal and cultural developments of any given epoch. More than in any other period, this can be clearly observed in what is referred to as the 'Long Sixties', which historians have dated as the period from 1958 to 1973/74.

This publication deliberately centres on the most important phenomena in fashion in the 'High Sixties' (1964–1969), as seen in international fashion photography and illustrations from the collections of the Sammlung Modebild – Lipperheidesche Kostümbibliothek (part of the Art Library of the National Museums in Berlin). In this, the largest specialist collection and library dedicated to the cultural history of clothing and fashion in the world, the array of media images of fashion dating from the Sixties has been greatly enriched thanks to a series of extensive donations and several acquisitions, of which the following are particularly noteworthy: the large donation of international fashion photographs by the Berlin newspaper, *Der Tagesspiegel*, the diverse estate of fashion journalist Carl-Heinz Bauer and the purchase of three fashion drawings by Antonio, the renowned illustrator, which was made possible by donations from MaxMara S.r.l. In addition to the original photographs and illustrations, this publication also includes several picture pages from fashion journals containing pictures of other important photographers such as Richard Avedon or Hiro.

Influences and Developments

Clear signs of a break from the past could already be felt at the end of the 1950s, which had been characterised by the feminine elegance of collections by the Parisian haute couture of Dior, Chanel, Balenciaga and other fashion designers. In the United States especially, as well as in Europe, a young generation with disposable income emerged, which no longer conformed to the fashion ideals of its parents. The influence of teenagers and students made itself felt in all fields of life, in politics, the economy and culture. The conflation of economic stability, social action and the blossoming of popular culture and mass consumption played a decisive role in shaping the fashion of the Sixties.

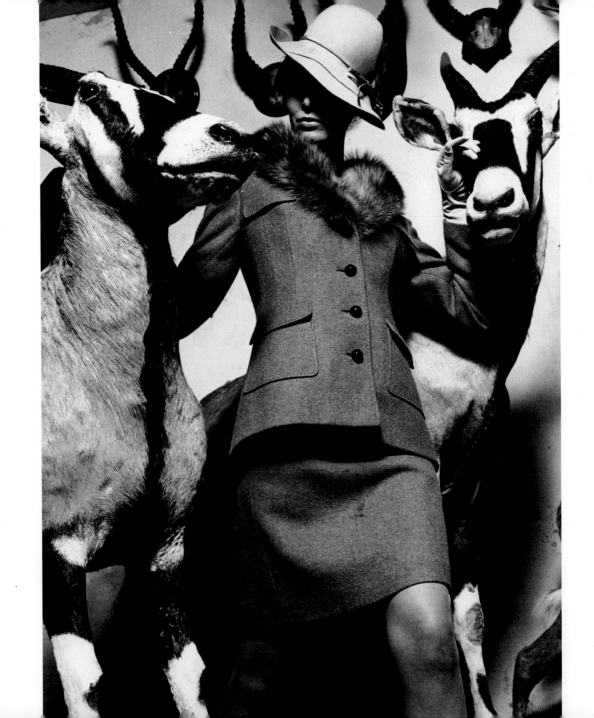

Andere Einflüsse und Entwicklungen, die hier lediglich stichwort-
artig angeschnitten werden können, sind die bahnbrechenden
technologischen Entwicklungen der Chemiefasern, der bemannte
Mondflug oder die zunehmende Verbreitung des Fernsehens. Die
Antibabypille erlaubte eine neue Offenheit der sexuellen Beziehun-
gen mit weitreichenden Wirkungen auf Familienstrukturen und die
Frauenemanzipation. Politisch wichtige Ereignisse waren die Wahl
von John F. Kennedy zum Präsidenten der Vereinigten Staaten von
Amerika, die dort eingeführten Bürgerrechte für Afroamerikaner,
der Bau der Berliner Mauer, der internationale Protest gegen den
Vietnamkrieg sowie die europäischen Studentenunruhen von 1968.
Eine zunehmende Internationalisierung im Kulturaustausch ermög-
lichte zu Beginn der 1960er Jahre die weltweite Verbreitung der
anglo-amerikanischen Popkultur ebenso wie ab 1966 die weltan-
schauliche Orientierung an den Religionen des Fernen Ostens und
die Entfaltung der Hippie-Kultur. Filme wie *La dolce vita* (1959,
F. Fellini), *A bout de souffle* (1960, J.-L. Godard), *Jules et Jim* (1962,
F. Truffaut), *Blow up* (1966, M. Antonioni), *Barbarella* (1968, R. Vadim),
2001: Odyssee im Weltraum (1968, S. Kubrick) oder *Easy Rider*
(1969, D. Hopper) sowie die ersten James-Bond-Filme lieferten prä-
gnante Vorbilder unterschiedlichster Art.

Modeaufstand der Jugend?
Allzu leicht entstehen im historischen Rückblick mythisch verklärte
Bilder mit falschen Polarisierungen und verkürzter Argumentation.
So sollte man sich davor hüten, die 1960er Jahre zum alleinigen
Reich der Jugendkulturen, von Pop, Konsum oder Hippie-Kultur zu
erklären. Faktisch stellte sich auch die modische Realität in wirt-
schaftlicher und kultureller Hinsicht je nach Land, Jahr und sozia-
lem Gefüge enorm facettenreich dar und bedürfte eingehender
Detailstudien. Einige Fakten lassen sich jedoch benennen, die in
den „High Sixties" voll ausgeprägt waren, wodurch die zuvor schon
anklingenden Umbrüche besonders offensichtlich wurden.

Dazu gehörte maßgeblich die Orientierung der Modemärkte an den
jungen Konsumenten: „Alle buhlen um die Gunst der Jungen, denn
nur was sie wollen, kaufen die Alten ein", beschrieb die Zeitschrift
Stern 1968 die Situation (11.2.1968, S. 26). Junge Menschen, nun
Teenager oder Twens genannt, galten als kaufkräftige Zielgruppe, die
Einkaufen als populäre Freizeitbeschäftigung schätzte und ihr Image

Other influences and developments, which can only be touched on
here in brief, include the groundbreaking technological advances
made by chemical fibres, the manned flight to the moon or the in-
creasing spread of television. The contraceptive pill heralded a new
openness in sexual relationships with far-reaching consequences
on family structures and women's liberation. Politically important
events included the election of John F. Kennedy as president of the
United States of America, the newly won civil rights for African-
Americans, the construction of the Berlin Wall, the wave of interna-
tional protest against the Vietnam War, as well as the student unrest
of 1968. An increasing internationalization in the cultural exchange
between countries facilitated both the global spread of Anglo-
American pop culture from the early Sixties onwards and, from
1966, a shift in worldview to include the spiritual influences of India
and the Far East, not to mention the spread of hippie culture. Films
like *La Dolce Vita* (1959, F. Fellini), *A bout de souffle* (1960, J.-L.
Godard), *Jules et Jim* (1962, F. Truffaut), *Blow Up* (1966, M. Anto-
nioni), *Barbarella* (1968, R. Vadim), *2001: A Space Odyssey* (1968,
S. Kubrick) or *Easy Rider* (1969, D. Hopper), as well as the first
James Bond films provided a variety of role models for cinema-goers
to be inspired by.

Youth Fashion Rebellion?
All too often, when reviewing the past, glorified images emerge
that are shrouded in myth, with facts falsely polarized in view and
presented only in part. We should be wary of declaring the Sixties
as solely the domain of youth culture, pop, consumerism or hippie
culture. An examination of the facts shows that from an economic
and cultural perspective, the reality in fashion differed enormously
from country to country, depending on the year and social structure,
and thus warrants detailed individual analysis. We can be sure of
some facts, however, which were indeed especially pronounced
in the 'High Sixties', in which the radical changes that had already
been looming came to the fore.

Principal among them is the fact that the fashion markets turned
their attention to young consumers: 'Everybody is courting the
young's favour, because parents are only willing to buy what they
actually want,' is how the magazine *Stern* described the situation
(11.2.1968, p.26). Young people, who were now known as teenagers

in einer ausgeklügelten Selbstinszenierung mit Hilfe von Kleidung, Accessoires, Make-up und Frisuren pflegte. Qualität zählte für sie weniger als Neuheit, weshalb der Markt von preiswerten Massenartikeln überschwemmt wurde. Modestil und Musikkultur gingen Hand in Hand, man zeigte sich bei einschlägigen Konzerten, frequentierte die „richtigen" Diskotheken und Partys in entsprechend konnotierter modischer Kleidung. Nach den Rock'n-Roll-Fans wurden am Ende der 1950er Jahre in Großbritannien die „Mods", abgekürzt für Modernists, prägend, die kosmopolitisch eingestellt waren. Die vorwiegend männlichen Mods trugen schmale italienische Anzüge von Brioni oder amerikanischen Casual Look mit Strickpullovern, fuhren Vespa-Motorroller, schwärmten für die französischen Filme der *Nouvelle Vague* und hörten amerikanische Jazzmusik, später auch die Beatles und die Rolling Stones. Mit der Orientierung an neuen Idealen warfen die Teenager die bislang gültigen Regeln des „guten Geschmacks" endgültig über Bord. Zur Mitte der 1960er Jahre waren ihre Leitbilder nicht länger Farah Diba oder Jackie Kennedy, sondern Brigitte Bardot oder das androgyne Fotomodell Twiggy.

Als weitere Tendenz lässt sich die sukzessive Ablösung von Paris als zentralem Ort der Modeinspiration benennen, wodurch weltweit gleichzeitig mehrere einander beeinflussende Moderichtungen existierten. Zwar blieb die französische Haute Couture für die Elite weiterhin vorbildhaft, parallel entwickelten sich jedoch die populäre Jugendmode nach Londoner Prägung, der avantgardistische „Italian Style" sowie ein internationaler Freizeitlook, bestehend aus Jeans, Pullovern und T-Shirts.

Eine dritte Neuerung der 1960er Jahre war die ausgeprägte Körperlichkeit, die in den „biederen" 1950er Jahren eher unterdrückt worden war. Die junge Mode exponierte nun den Körper in einer zuvor nicht erlaubten Weise, wobei die Frauenbeine den Hauptblickfang ausmachten. Der Minirock – nur tragbar in Kombination mit den neu erfundenen Strumpfhosen – entblößte die Knie und einen Gutteil der Oberschenkel. Solch offen sexuelle Anspielungen der Mode stießen in traditionellen Kreisen auf erbitterten Widerstand, wurden aber auch als Symbole für die neuen Freiheiten gefeiert. Transparente, eng anliegende Oberteile, hautfarbene Unterwäsche und tiefe Rückendekolletés waren weitere modische

Details, die es für die meisten Frauen notwendig machten, ihre Figur durch Diäten entsprechend dem vorbildlichen Körperideal zu formen.

Ein vierter Umstand, die weltweit erfolgreiche Entwicklung neuer, elastischer Chemiefasern – mit Markennamen wie Dralon, Perlon, Trevira, Diolen und Lycra – ermöglichte es den Modedesignern, extrem körpernahe Schnitte mit gleichzeitiger Bewegungsfreiheit zu verbinden. Die entsprechenden Textilien ließen sich gut bunt färben bzw. gemustert bedrucken oder zu glänzenden Oberflächen veredeln, waren pflegeleicht und zudem preiswerter als Seide oder Wolle.

Modestädte London – Paris – Berlin

Gemäß den Sammlungsschwerpunkten werden in diesem Buch vor allem Modebilder aus London, Paris und Berlin gezeigt, deshalb seien kurz die Besonderheiten des jeweiligen Modestils vorgestellt.

London stand in den 1960er Jahren wie keine andere Metropole für die junge Mode, die einen fast kindlichen, teilweise exaltierten Stil pflegte. Bereits 1955 hatte Mary Quant ihren ersten Laden eröffnet, mit ihren selbst geschneiderten Minikleidern wurde sie im folgenden Jahrzehnt extrem erfolgreich. Der typische Londoner Boutiquenstil von Carnaby Street und King's Road brachte bunte Kleider, kindlich anmutende Silhouetten und romantische Rückgriffe auf den Großmutterstil auf den Markt. Die jungen Männer versorgte John Stephen ab 1957 mit seiner Boutique „His Clothes", 1964 eröffnete Barbara Hulanicki die einflussreiche Biba Boutique. Androgyne Topmodels aus London waren Jean Shrimpton und die kindliche Twiggy, die binnen kurzem weltweit Erfolg hatten. London wurde als „Swinging City" gefeiert, wo junge Mode, Musik, Film und Fotografie zur Blüte kamen.

Die Pariser Couturiers konnten sich dem Londoner Einfluss nicht entziehen. Vor allem die junge Generation – Yves Saint Laurent, André Courrèges, Pierre Cardin, Paco Rabanne und andere – bot avantgardistisch zeitgemäße Kollektionen an und eröffnete eigene Prêt-à-Porter-Abteilungen mit preiswerteren Modellen. Der Pariser Stil war jedoch zumeist architektonisch-geometrisch und von exzellenter Verarbeitung geprägt: Strenger Space-Look, männlich

or twenty-somethings, suddenly became a target group in their own right, with their own disposable income, for whom shopping was a prized, popular leisure activity and whose image was cultivated in an elaborate performance with the help of such props as clothing, accessories, make-up and hair styles. For this group, quality mattered less than originality, which led to the market being awash with affordable, mass-produced goods. Fashion styles and pop music culture went hand in hand. Individuals did their best to be seen at the appropriate concerts, frequented the 'right' discotheques and parties in fashionable clothing that had all the 'right' connotations. In the late 1950s, the 'mods', with their cosmopolitan outlook on life, became the defining youth movement in Great Britain. The predominantly male mods wore tight-fitting Italian suits made by Brioni or copied the American preppy look by sporting knitted pullovers, riding around on Vespa scooters, avidly watching French films of the *Nouvelle Vague* and listening to American jazz music, later also to The Beatles and The Rolling Stones. By adopting these new ideals, teenagers threw the previous rules of 'good taste' out the window. By the mid 1960s, their role models were no longer Farah Diba or Jackie Kennedy, but rather Brigitte Bardot or the androgynous photo model Twiggy.

Another significant trend was the dissipation of the fashion world. Paris was no longer the primary source of its inspiration and instead several styles existed around the world, each influencing one another. It is true that French haute couture remained the benchmark for the elite, but concurrent to this other styles included: London-inspired popular young fashions, the avant-garde 'Italian Style' as well as an international casual look with jeans, sweaters and T-shirts.

A third novelty for the Sixties was the distinct corporeality of its time, a factor that had been rather suppressed in the more conservative 1950s. The new fashion now exposed the body in a way that had previously been impermissible, with one of the most eye-catching features now a woman's legs. The miniskirt – only wearable in combination with the newly invented tights – revealed the knee and a good part of the thigh. Such openly sexual playfulness in fashion was bitterly opposed in traditional circles, but was equally celebrated as a symbol of new freedoms. See-through, tight-fitting tops, flesh-colored underwear and low back dresses were further fashion

details that made it necessary for most women to shape their figure by dieting to fit the ideal body image.

A fourth point worth mentioning is the successful development of new, elastic chemical fibres around the world – with brand names such as Dralon, Perlon, Trevira, Diolen and Lycra – that enabled fashion designers to combine figure-hugging cuts with great freedom of movement. Such textiles could be dyed in vibrant colors, be pattern-printed with relative ease, treated so their surfaces shimmered, were easy to wash and in addition were less expensive than silk or wool.

Fashion Capitals London – Paris – Berlin
In keeping with the nature of the collection, this book principally features fashion pictures from London, Paris and Berlin, and for this reason it is worth giving a short introduction to the special characteristics of each particular style first.

In the Sixties, more than any other city, London was the symbol for young fashion and boasted an almost childlike, in part eccentric style. Mary Quant opened her first shop in 1955 and she went on to become extremely successful a decade later with her own line of mini dresses. The typical London boutique fashions from Carnaby Street and The King's Road brought colorful dresses, silhouettes bordering on the childlike and romantic evocations of a grandmotherly style of dress onto the market. For young men there was John Stephen and his boutique, His Clothes, which opened in 1957. And in 1964 Barbara Hulanicki opened her influential Biba Boutique. Jean Shrimpton and her childlike contemporary, Twiggy, were androgynous top models from London who become an overnight success around the globe. London was celebrated as 'the swinging city' where young people's fashion, music, film and photography flourished.

Even the Parisian couturiers could not escape London's influence. The younger generation especially – Yves Saint Laurent, André Courrèges, Pierre Cardin, Paco Rabanne – offered avant-garde collections to suit the times and opened their own prêt-à-porter departments, selling more affordable designs. The Paris style was, however, largely architectural and geometric in form and was

inspirierte Hosenensembles und romantische Silhouetten standen gleichberechtigt nebeneinander.

Die florierende deutsche Modebranche mit ihrem Zentrum in Berlin war im europäischen Wettbewerb seit den 1950er Jahren gut aufgestellt und bot sowohl Konfektion aller Genres als auch hochwertige Modellkleidung nach Pariser Vorbild an. Zu den eingeführten Berliner Couturehäusern wie Gehringer & Glupp, Schwichtenberg und Staebe-Seger kamen erfolgreiche jüngere Modeschöpfer wie Detlev Albers, Heinz Oestergaard oder Uli Richter. Modische Konfektion führten in Berlin die Firmen Studio-Dress oder Evelyn-Kleider, in Westdeutschland Hauser-Modelle, Lürman oder Lauer-Böhlendorff. Nach dem Bau der Berliner Mauer erlitt die Branche allerdings einen starken wirtschaftlichen Einbruch durch den folgenschweren Zerfall des ursprünglich zwischen Ost und West aufgeteilten Produktionssystems.

Zeitschriften und Modebilder
Parallel zum Modeumbruch der 1960er Jahre entwickelten sich neben den traditionellen Modezeitschriften in allen Ländern zahlreiche neue Publikumsjournale, die sich in Inhalt und Form erheblich vom bisherigen Angebot unterschieden. Auf die Belange der jungen Frauen zugeschnittene Zeitschriftentitel waren die französische *Elle*, die englischen *Petticoat* und *Queen*, die deutschen *Petra* und *Brigitte*. Auch für den modischen Mann lagen spezielle Hefte vor, darunter *Lui*, *Arbiter*, *Sir*, *Club* oder *Gentlemen's Quarterly*. Mit *twen* erschien in der BRD von 1959 bis 1971 ein gestalterisch wie inhaltlich progressives Heft, das zum Leitbild für eine ganze Generation wurde. Diese Printmedien trugen neben Film und Fernsehen enorm zur Kommerzialisierung der neuen Moden bei.

Die Modefotografien der „High Sixties" sind imageträchtige Bildinszenierungen, die ein breites Repertoire lebendiger Posen zeigen: breitbeinig stehend, leger sitzend, surreal verschlungen oder tänzerisch gestikulierend. Häufig sind die Fotomodelle angeschnitten, stehen selbstbewusst und dem Betrachter in die Augen blickend im Bild. Ihre Präsenz ist exponiert und körperlich, nichts wird versteckt. Viele Aufnahmen entstanden im modernen Stadtraum, so dass die neue Mode mit der zeitgenössischen Architektur korrespondiert. Bei aller Unterschiedlichkeit der fotografischen Handschrift zeigt sich

eine deutlich größere Experimentierfreude als noch in den 1950er Jahren, etwa durch surreale Studioarrangements, vielseitige Posen und Mimik, fototechnische Bearbeitungen und radikale Ausschnitte.

Die Modeillustratoren verlieren in den „High Sixties" an Bedeutung, wenngleich noch viele deutsche Tageszeitungen mit Zeichnern zusammenarbeiten, darunter Walter E. Voigt, Hannelore Brüderlin, Lilo Kittel oder Gerd Hartung. Einzig der junge Antonio Lopez war international erfolgreich und kann mit seinem von der Pop-Art wie auch vom Jugendstil geprägten Stil die Lebendigkeit des Metiers unter Beweis stellen. Seine Kompositionen verkörpern den Geist der 1960er Jahre in bester Weise: „Alles ist jung, strahlend und frisch wie die Palette der neuen Mode." (*Stern*, 7.3.1965, S. 27)

Stilistisch sind die „High Sixties" von ganz verschiedenen Modesilhouetten geprägt, die im nachfolgenden Bildteil thematisiert werden: Die elegante Lady steht neben dem Girl, der futuristische Space-Look neben nostalgischer Romantik und folkloristisch gefärbter Hippie-Mode, plakative Pop- und Op-Art-Modelle neben sportlichen Freizeitoutfits. Modische Männerkleidung, Textildesign, Make-up, Frisuren und Hüte sowie die vielgestaltige Partykleidung sind weitere Themen.

Adelheid Rasche

characterized by excellent craftsmanship. Rigid 'space look' outfits, trouser ensembles with a masculine bent and romantic silhouettes all co-existed with equal potency.

In the 1950s, the flourishing German fashion industry with its centre in Berlin found itself well placed among its European rivals, with the manufacture of all genres as well as high-quality clothing following the Parisian example. Joining the established Berlin fashion houses of the likes of Gehringer & Glupp, Schwichtenberg and Staebe-Seger came a wave of successful younger fashion designers such as Detlev Albers, Heinz Oestergaard or Uli Richter. The companies Studio-Dress or Evelyn-Kleider manufactured high-quality garments in Berlin itself, while firms like Hauser-Modelle, Lürman or Lauer-Böhlendorff were based in West Germany. However the construction of the Berlin Wall meant that the industry suffered a significant economic collapse due to the breakdown in the production system which was spread across both sides of the city.

Magazines and Fashion Images

Parallel to the radical changes in fashion in the Sixties, all countries saw the rise of new journals alongside the traditional fashion magazines, which were vastly different in terms of both content and form to those previously on offer. Tailored to the concerns of young women, these new titles included *Elle* in France, *Petticoat* and *Queen* in the United Kingdom and *Petra* and *Brigitte* in Germany. Special publications for their fashionable male counterparts also hit the market, among them: *Lui*, *Arbiter*, *Sir*, *Club* or *Gentlemen's Quarterly*. *Twen*, which ran from 1959 to 1971 in the Federal Republic of Germany, was a progressive magazine, both in terms of its layout and content, and set the standard for a whole generation. This print media made an enormous contribution to the commercialization of the new fashions, as did film and television.

Fashion photographs from the High Sixties were often powerful, image-laden set pieces that displayed a wide repertoire of lively poses: with models either standing with feet firmly wide apart, leisurely reclining, poised in surreal contortions or gesticulating in dance-like movements. The photo models are often truncated, their stance radiates confidence and they look the viewer directly in the eye. The body is revealed, often sensually, nothing is hidden. Many shots were taken in modern urban spaces so that the new fashions correspond neatly with the architecture of the day. In all the widely differing photographic styles, the images share one thing: their markedly accentuated desire for experimentation (especially when compared to the photographs of the 1950s), as evidenced in surreal studio sets, complex poses and facial expressions, technical manipulation of the prints and radical cuts.

Fashion illustrators had a waning influence in the High Sixties, even though many German newspapers continued to work with illustrators, among them Walter E. Voigt, Hannelore Brüderlin, Lilo Kittel and Gerd Hartung. The young Antonio Lopez was the sole exception, becoming an international success, able to demonstrate the vivid potential of his profession with his style which took its inspiration from pop art as well as art nouveau. His compositions embodied the spirit of the Sixties in the best way possible: 'Everything is young, radiant and fresh, just like the palette of fashion today.' (*Stern*, 7.3.1965, p. 27)

From a stylistic viewpoint, the High Sixties are characterized by several, totally different fashion silhouettes that are examined in more detail in the following sections of this book: the elegant lady appears alongside the girl, the futuristic 'space look' alongside nostalgic romanticism and hippie fashions in folkloric colors, bold pop and op art models feature alongside sporty casual outfits. Further themes include: men's clothing, textile design, make-up, hairstyles and hats, as well as various forms of party dress.

Adelheid Rasche

Damenhaft und Ladylike

Zu Beginn der 1960er Jahre war die internationale Mode weitgehend dem Erbe Christian Diors und dem eleganten Ideal der 1950er Jahre verpflichtet. Die Zeitschrift *Constanze* schrieb noch 1964 unter den Stichwörtern „damenhaft und ladylike": „[…] man denkt an Würde, an dezente Zurückhaltung, an Selbstsicherheit und Ausgeglichenheit, nicht nur in der persönlichen Ausstrahlung, sondern auch in der äußeren Erscheinung." Entsprechend sollte der Kleiderstil vornehm, dezent und unauffällig sein; beliebt waren insbesondere Ensembles wie Kostüme, Jackenkleider, Complets mit den obligatorischen Accessoires Handschuhe, Handtasche und Hut. Mäntel bzw. Jacken trug man mit schmeichelndem Schalkragen oder mit Pelzbesatz an Kragen und Manschetten. Gedeckte Farben und Pastelltöne waren beliebt, die Rocklänge blieb gemäßigt, dreiviertellange Ärmel gaben einen frischen Akzent.

Mitte der 1960er Jahre begann sich der Umschwung von der damenhaften Eleganz hin zum jugendlich bestimmten Modeideal durchzusetzen. Die Verunsicherung der erwachsenen Kundinnen war deutlich spürbar und sie fragten wiederholt in Leserbriefen an Zeitschriftenredaktionen, ob Minimode, farbige Stoffmuster oder die legeren Jersey- bzw. Hemdblusenkleider, mit Kopftuch und Turban kombiniert, für eine über 30-jährige Frau tragbar seien. Generell galt nun auch für die reifere Frau, dass eine schlanke Figur sowie eine jugendliche Lebenseinstellung die maßgeblichen Faktoren für ihre modische Erscheinung waren. Im Februar 1968 fasste eine Reportage im *Stern* diesen radikalen Wandel knapp zusammen: „Es ist nicht mehr gefragt, elegant zu sein. Eleganz ist mausetot, sogar das Wort schon vergessen. […] Was lebt, schlank und wach und tüchtig, ist die unabhängige Frau, fähig ihr Leben selbst zu meistern, frei in ihrem Beruf, in ihren Ansichten, in ihrer Liebe. Und vor allem: sie ist jung. Wenn sie Glück und Disziplin hat, fünfzig Jahre lang." AR

Ladylike

At the beginning of the Sixties, much of international fashion was still indebted to the heritage of Christian Dior and the ideal of elegance that had dominated the Fifties. As late as 1964, the magazine *Constanze* wrote under the heading 'Ladylike' that this type of outfit evoked images '[…] of dignity, of subtle restraint, of self-confidence and balance, not only in terms of personal charisma, but also regarding outward appearance.' The dress style was to be elegant, subtle and unassuming: ensembles such as suits and jacket dresses enjoyed great popularity, and an outfit was never complete without the obligatory accessories of gloves, handbag and hat. Coats and jackets were worn with flattering shawl collars or fur trimmings on collars and cuffs. Muted tones and pastel colors were popular, skirt lengths remained moderate, three-quarter sleeves provided a fresh accent.

Around the middle of the Sixties, fashion took a turn away from ladylike elegance towards an ideal dominated by youthfulness. Adult customers were evidently unsettled by this and repeatedly wrote letters to fashion editors, asking whether miniskirts, brightly colored patterns, or the casual jersey and shirtwaist dresses combined with headscarves or turbans were really wearable options for women over 30. The mature woman now had to accept that, as a general rule, a slim figure and a youthful attitude to life had become the defining criteria of fashionable appearance. In 1968, an article in *Stern* summarized this radical change in a few words: 'Being elegant is no longer fashionable. Elegance is as dead as a doornail, the word itself has already been forgotten. […] The independent woman is alive and kicking – slim and awake and industrious – able to be master of her own life, free in her job, in her attitudes, in her love. And above all: she is young. With some luck and discipline, she'll be young for fifty years.' AR

Helles Wollkostüm / Light wool suit, 1963
Yves Saint Laurent, Paris

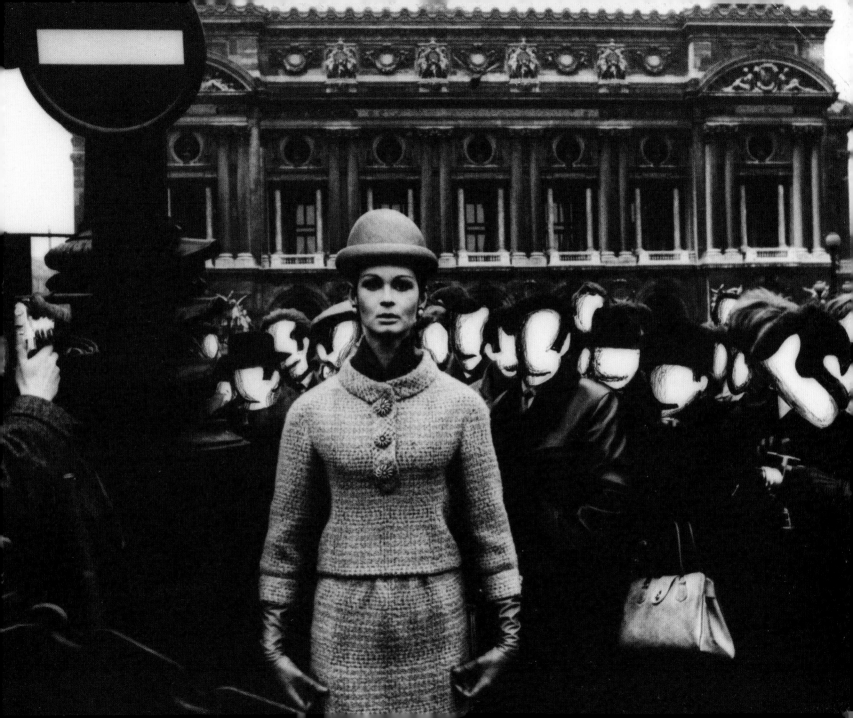

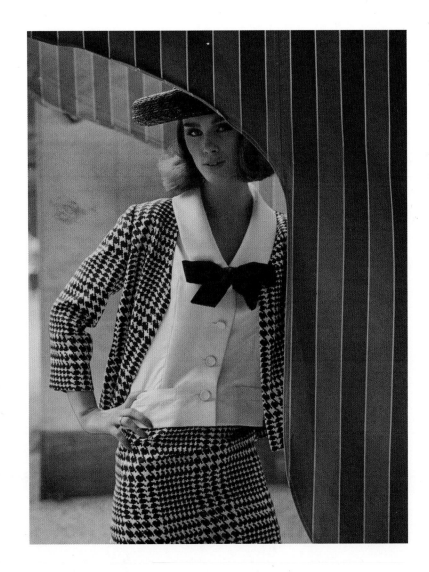

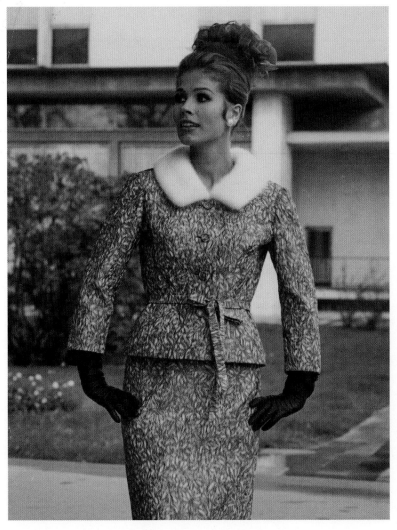

Sommerkostüm / Summer suit, 1964
Detlev Albers, Berlin

Cocktailkostüm mit Nerzkragen / Cocktail suit with mink collar, 1964
Schwichtenberg, Berlin

Complets / Ensembles,
um / around 1964

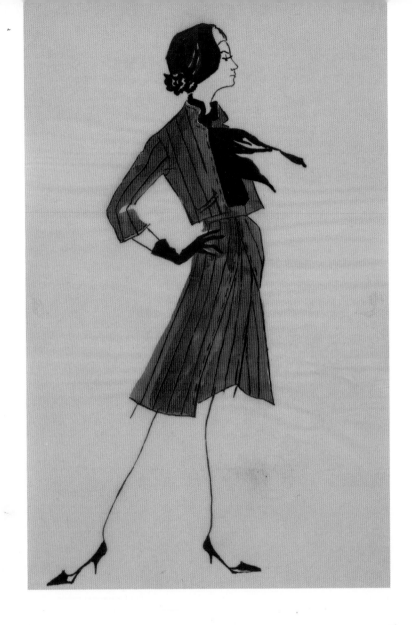

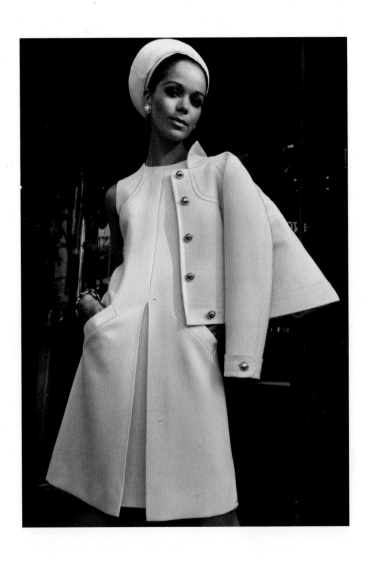

Entwurf für ein Sommerkostüm, um 1967 / Design for a summer suit,
around 1967. Lette Verein Berlin

Elegantes Jackenkleid / Elegant two-piece, 1968
Queisser-Modelle, München / Munich

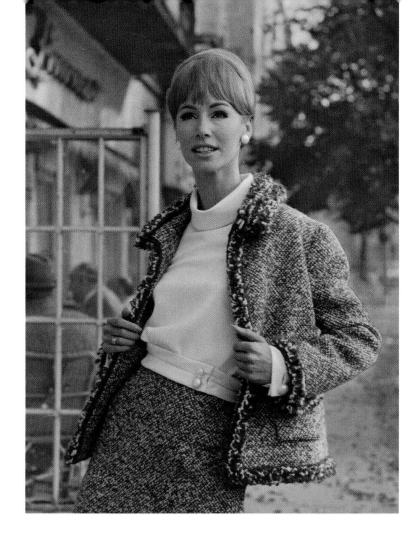

Tageskostüm / Day suit, 1964
Uli Richter, Berlin

Strickkleid mit Halskrause / Knitted dress with neck ruffle, 1964
Patrick de Barentzen Alta Moda, Rom / Rome

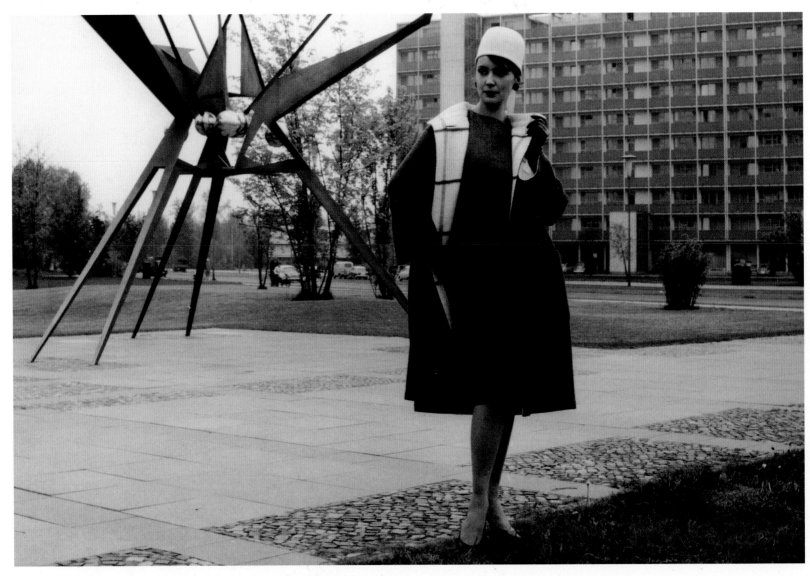

Complet mit kariertem Futter / Ensemble with checked lining,
o. J. / n.d. Uli Richter, Berlin

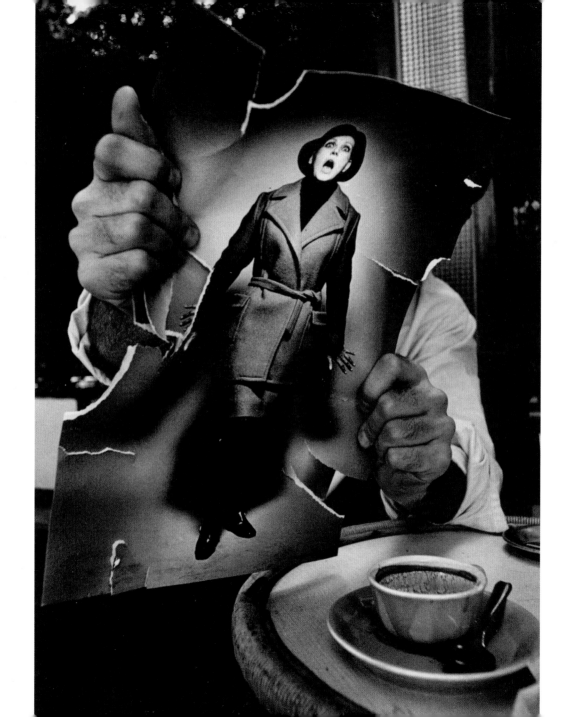

Wollkostüm / Wool suit, 1966
Modell: unbekannt /
Design: unknown

Just a Girl: Junge Mode

„Nie war die Frau jünger als in diesem Frühling: ein Twen, ein Teen, ein Kind in Kinderkleidern, Babyhängern, Strampelhosen", las man im Februar 1968 im *Stern*. Im Verlauf der 1960er Jahre hatte sich die Jugend – allein in Deutschland gab es gut 7 Millionen Menschen zwischen 14 und 24 Jahren – zur kaufkräftigsten Gruppe entwickelt, die im Schnitt 80% ihres Geldes für Mode ausgab. Attraktive Kleidung gehörte für sie maßgeblich zum erfolgreichen Auftritt: Ihre Leitbilder waren Film- und Fernsehstars, Musiker und Mannequins. So orientierte man sich an Twiggy und Grace Coddington aus England, die mit ihren androgynen, extrem schlanken Körpern allerdings nur schwer zu erreichende Idealfiguren waren.

Die junge Mode unterschied sich komplett vom damenhaft geprägten Stil der Müttergeneration. Insbesondere der englische „Chelsea-Look", durch Mary Quants originale Entwürfe geprägt und von zahllosen Londoner Boutiquen verbreitet, wurde ab 1964 in ganz Europa begeistert aufgenommen. Auch die Pariser Modeschöpfer – allen voran Pierre Cardin und André Courrèges – boten mehr und mehr junge Mode an. Selbst die Couturehäuser brachten Prêt-à-Porter-Kollektionen auf den Markt. „Alles ist superkurz, superfit. Flache feste Stoffe, klare Farben [...], flache Spangenschuhe, Strumpfhosen", so beschrieb der *Stern* die Frühjahrskollektion 1968 von Courrèges.

Im Rückblick lässt sich als wesentlichste Neuerung der jungen Mode der freizügige Umgang mit dem – idealerweise schlanken – Körper nennen: extrem kurze Miniröcke, kombiniert mit auffälligen Strumpfhosen oder Lackstiefeln, sehr eng geschnittene farbige Kostüme, dazu knappe Pullover. Als zweite konträre Silhouette setzte sich der „Little Girl-Look" durch, mit schwingenden Babydolls bzw. Hängerkleidern mit Unterziehpullover. Das Hippiemädchen der späten 1960er Jahre kleidete sich in romantische Blumenkleider, folkloristische Naturfelljacken oder weit schwingende Hosen. AR

Just a Girl: Youthful Fashion

In February 1968, *Stern* magazine proclaimed that: 'Grown women have never been as young as they are this spring: twenty-somethings, teens, children in children's clothing, in baby smock dresses, in rompers.' Over the course of the Sixties, in fashion at least, the young generation was catapulted into being the group with the most purchasing power. In Germany alone there were 7 million individuals between the ages of 14 and 24, who on average spent 80% of their money on fashion. For them, attractive clothing was essential for their success in life: their role models were stars from the world of film, television and pop as well as fashion models. Accordingly, they followed the looks of Twiggy and Grace Coddington from the United Kingdom, who with their androgynous, extremely thin figures, were anything but easy to emulate.

Young fashion differed completely from the lady-like style of the generation before. From 1964 onwards, the English 'Chelsea girl look', as defined by Mary Quant's original designs and taken up by countless London boutiques, became a hit right across Europe. Parisian fashion designers, and Pierre Cardin and André Courrèges especially, also created more and more designs specifically for the young. Even the couture houses brought prêt-à-porter collections onto the market. This is how *Stern* summed up Courrèges's 1968 spring collection: 'Everything is super short, super tight. Flat, stiff materials, pure colors [...], flat shoes in the style of Mary Janes, tights.'

In retrospect, the most significant new development in young fashion was the liberal approach to the (ideally thin) body: as seen in extremely short mini-skirts, combined with loud tights or patent leather boots, or very tightly cut, colorful suits, worn with tight pullovers. A second, contrasting silhouette subsequently emerged in the form of the 'little girl look', with voluminous babydolls or sack dresses worn with long-sleeved tops underneath. The hippy girl of the late Sixties dressed in romantic floral dresses, folkloric natural fur jackets or widely flared trousers. AR

Kostüm mit Minirock / Suit with miniskirt, 1964
Modell: unbekannt / Design: unknown

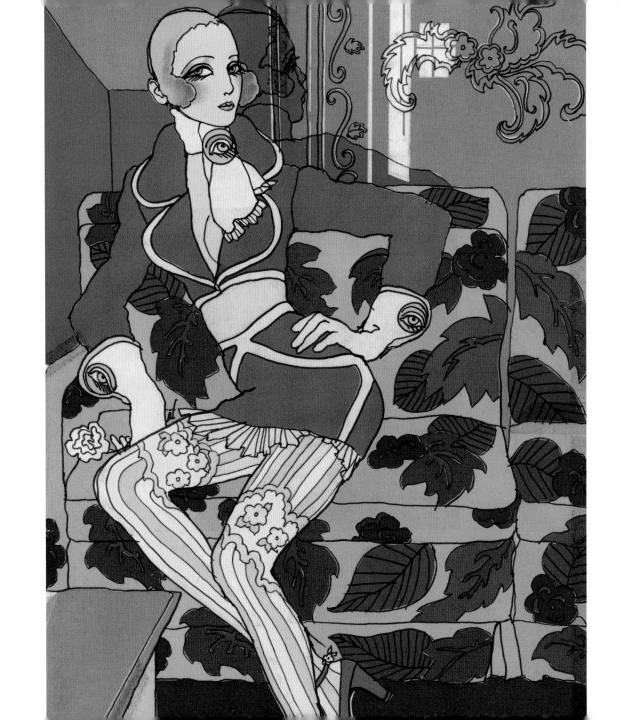

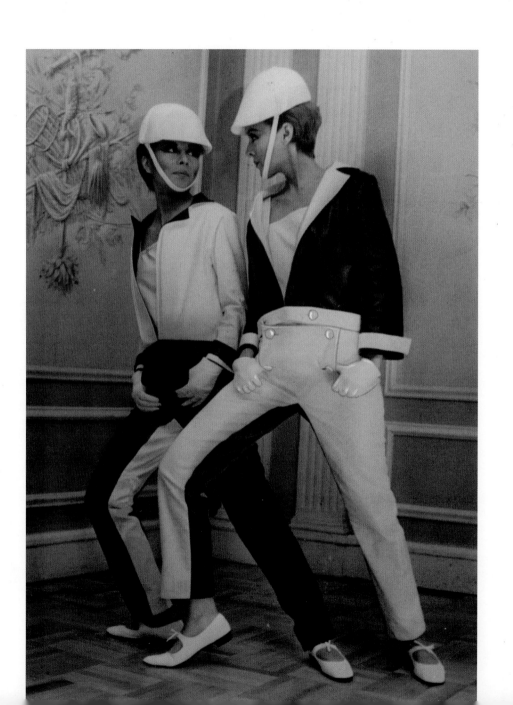

Sportliche Ensembles / Sporty
ensembles, 1965. André Courrèges
Haute Couture, Paris

Flaschengrüner Mantel / Bottle-green
coat, 1967. Simonetta, Rom / Rome

Helles Minikleid / Pale mini dress, 1967
Modell: unbekannt / Design: unknown

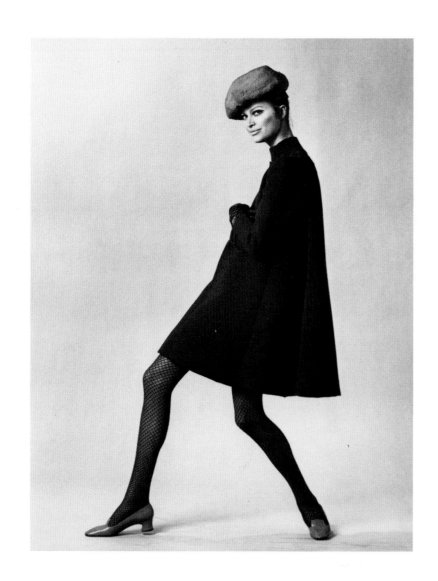

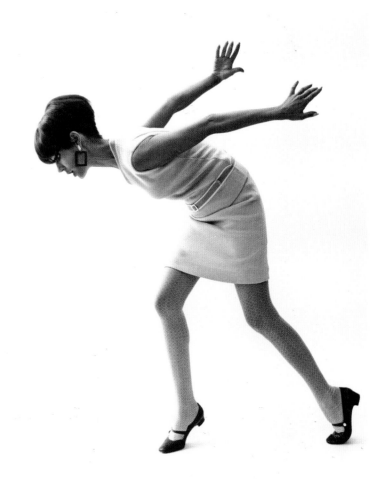

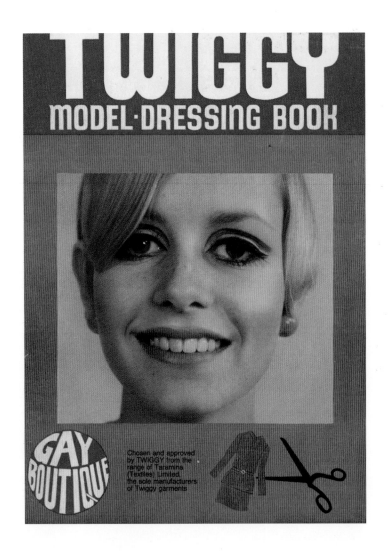

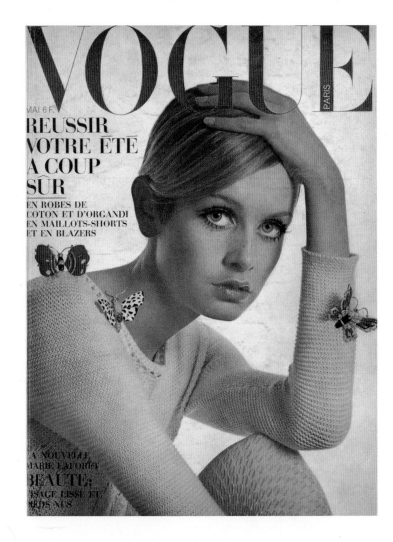

Twiggy Model-Dressing Book. London, 1967

Vogue Paris, Mai / May 1967
Fotomodell / Model: Twiggy

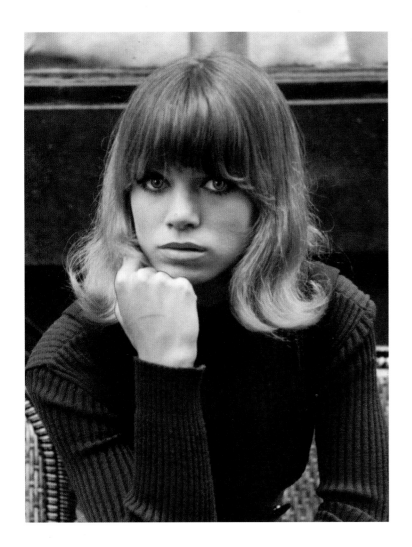

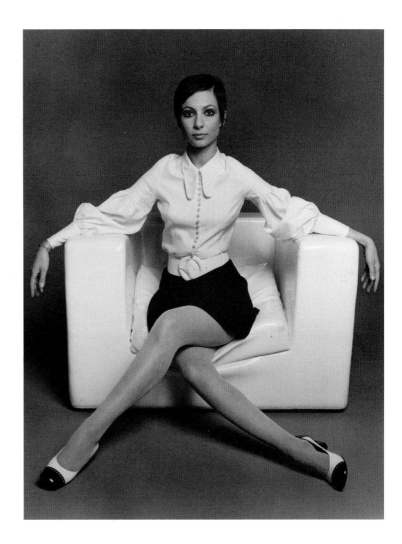

Phyllis aus Paris im Strickpulli / Phyllis from Paris in knitted sweater, 1966

Ensemble mit dunklem Minirock / Ensemble with dark miniskirt, 1965
Uli Richter, Berlin

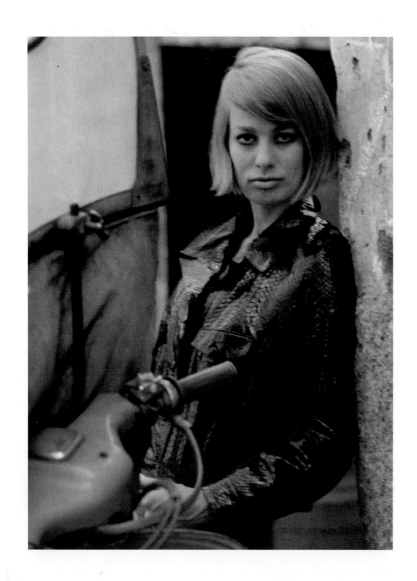

Dunkle Jacke aus Schlangenleder / Dark snakeskin jacket, 1964
Gill Latore, Rom / Rome (?)

Kurzmantel aus Bastardvelours / Short velour coat, 1968
Regnier

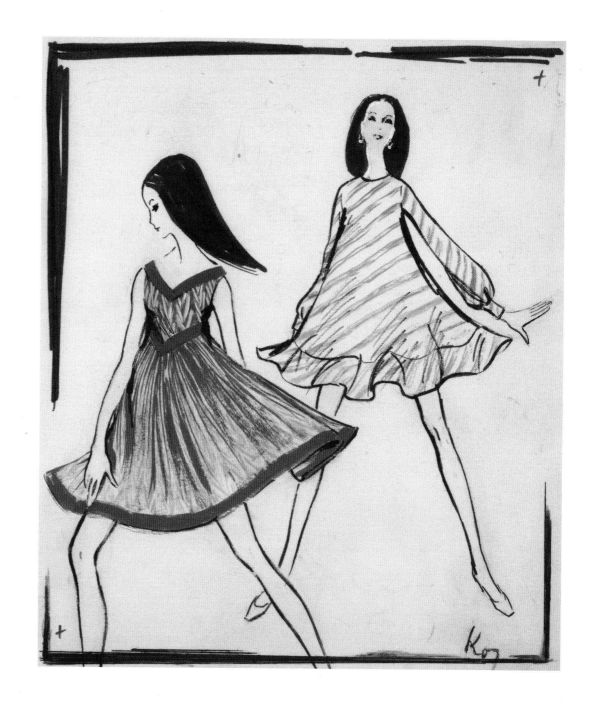

Tanzkleider / Dancing dresses, 1967
Staebe-Seger, Berlin und / and
Jean Patou, Paris

Take me to the moon: Space-Look

In direktem Zusammenhang mit der Weltraumfahrt lancierte der Pariser Couturier André Courrèges im Herbst 1964 den „Space-Girl-Look", der in Schnitt und Material zukunftsorientiert und betont jugendlich war. Die französische *Vogue* bezeichnete seine Modelle in ihrer September-Ausgabe als „chirurgische Reinheit, ergänzt von Aufsehen erregenden, glitzernden Pailletten und schwarzem, glänzendem Lackleder". Courrèges kleidete die Frauen von Kopf bis Fuß in Weiß und verwendete glänzende Kunststoffe. Neben Weiß – laut Courrèges die Reflektion des Lichts – war Silber als Widerschein des Mondes die dominante Farbe seiner Mode. Courrèges nutzte für seine kurzen Kleider, für Kostüme und Hosenanzüge auch Doubleface-Stoffe aus Wollgabardine und Baumwollsatin. Diese Wendestoffe mit übersteppten Nähten konnten umgekehrt werden; kombiniert wurden sie mit Matelassé-Lamé, Vinyl, glänzendem Knautschlack oder Sankt Galler Spitze. Applikationen fertigte er aus Rhodoïd-Plättchen, silbernen Pailletten sowie glänzenden Vinylscheiben. Als gelernter Brückenbauingenieur besaß Courrèges einen guten Blick für Konstruktionen in der Formgestaltung. Die perfekten Proportionen seiner Entwürfe betonte er durch geometrische Linien, ergänzt durch klar abgegrenzte Farbkontraste, bestehend aus Blockstreifen, Absteppungen und Paspelierungen. Im Frühjahr 1965 betraten Courrèges „Mondmädchen" die Modebühne. Zu kurzen, leicht ausgestellten Kleidern kombinierte der Couturier schneeweiße Wollmäntel mit eckigem Kragen, futuristische Sonnenbrillen mit Augenschlitzen, eckige Hüte mit Kinnriemen, kurze, weiße Handschuhe sowie transparente, wadenlange Kniestrümpfe und zehenfreie, weiße Stiefelchen.

Der Weltraum-Look stand Mitte der 1960er Jahre auch bei Cardin, Féraud und Ossie Clark im Vordergrund. Cardins Kollektion „Cosmocorps" von 1967 definierte sich durch Plastik-Overalls, Vinyljacken mit Reißverschluss, futuristische Helme mit Sichtfenstern sowie hautenge, metallisch glänzende Bodysuits. Elemente dieses Space-Looks à la Courrèges und Cardin wurden von der Bekleidungsindustrie ungehend hemmungslos kopiert und fanden weite Verbreitung. HR

Take Me to the Moon: The Space Look

In autumn 1964 and as a direct influence of space travel, the Parisian couturier, André Courrèges, launched the 'space-age look', which was both visionary and markedly youthful in cut and material. In its September issue, French Vogue described his designs as being of 'clinical purity, complimented by eye-catching, shimmering sequins and black, shiny patent leather'. Courrèges clothed his models from head to toe in shimmering white synthetics. Besides white (which according to Courrèges embodied the reflection of light), the color silver also served as the dominant color of his fashion, evoking the moon's reflection. For his mini-dresses, women's suits and trouser suits, Courrèges also used double faced fabrics made of wool gabardine and sateen. These reversible fabrics with top-stitched seams could not only be turned inside out, but were combined with matelassé lamé, vinyl, shiny crushed patent leather or St. Gallen lace. In addition to this, Courrèges created appliqués made from slivers of Rhodoid plastic plating, silver-colored sequins and shimmering vinyl discs. Having studied to become a bridge-building engineer, Courrèges was endowed with a good eye for technical construction in design. The perfect proportions of his designs were reinforced by the geometry of the lines and complimented by color contrasts with a bold separation of color that took the form of thick stripes, quilting and piping. In spring 1965, Courrèges' 'moon girls' stepped out onto the catwalk for the first time. The designer combined short, slightly flared dresses with snow-white wool coats with angular collars, futuristic sunglasses with eye slits, angular hats with chin straps, short, white gloves and see-through, knee-length tights and open-toed white boots.

By the mid Sixties, the space look had also become a prominent feature for Cardin, Féraud and Ossie Clark. Cardin's 'Cosmocorps' collection from 1967 was defined by plastic overalls, vinyl jackets with zips, futuristic helmets with tinted visors as well as skin-tight, glistening metallic-colored bodysuits. Almost immediately, elements of Courrèges' and Cardin's 'space-age look' were unscrupulously copied and widely disseminated by the clothing industry. HR

Kleid aus Metallplättchen / Dress made of metal plates, 1966. Paco Rabanne, Paris

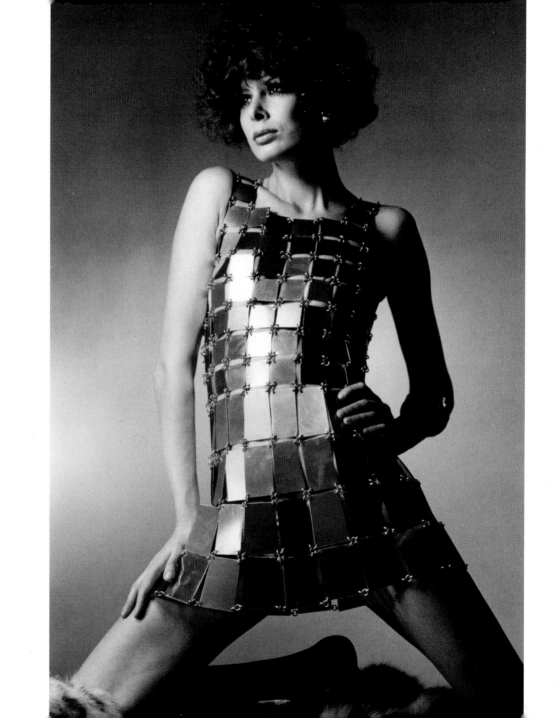

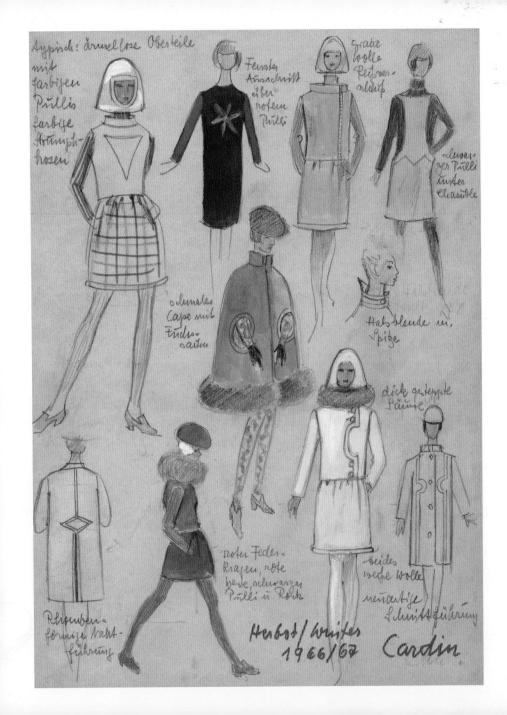

Kollektionsübersicht / Collection overview, 1966/67 Pierre Cardin, Paris

Cocktailkleid aus Lamé mit Tunika / Lamé cocktail dress with tunic, 1966 Roberto Capucci, Rom / Rome

Silberblauer Regenmantel aus Vinyl / Silver-blue vinyl raincoat, 1967. Simonetta & Fabiani, Paris-Rom / Paris-Rome

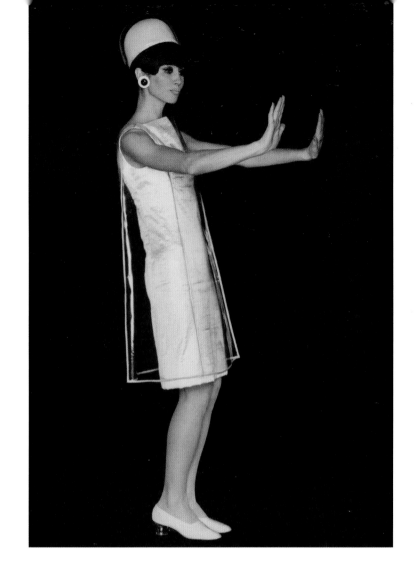

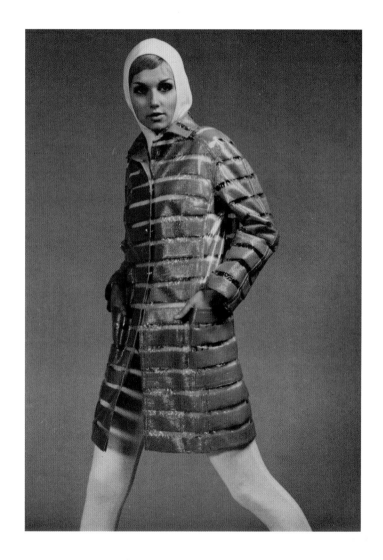

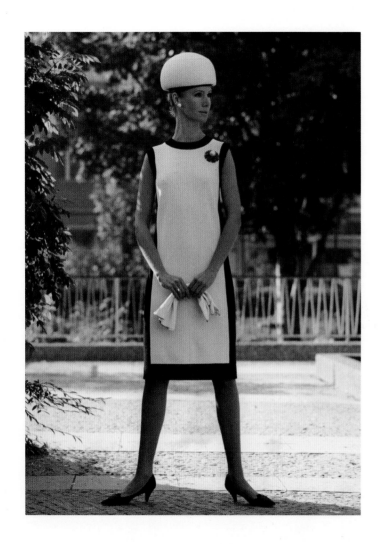 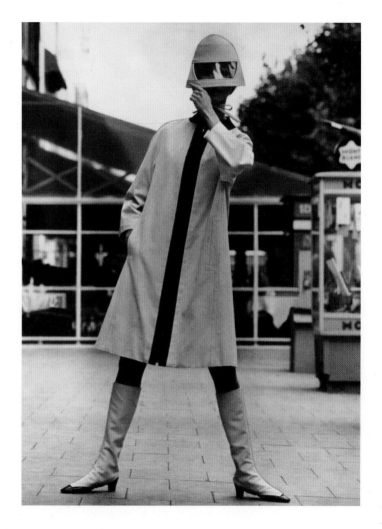

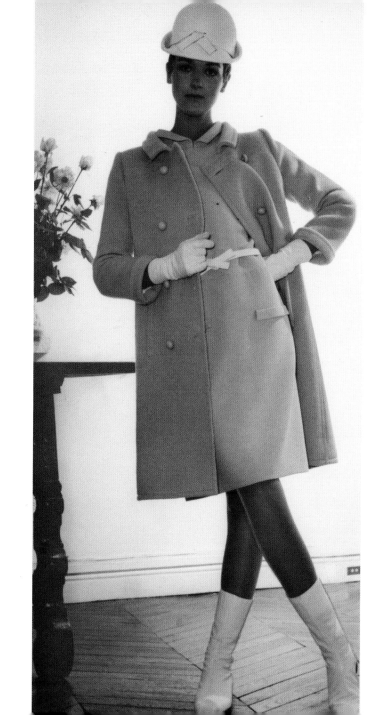

Sommerkleid / Summer dress, 1966
Uli Richter, Berlin

Mimosengelber Mantel aus Popeline /
Mimosa yellow poplin coat, 1966
Staebe-Seger, Berlin

Ensemble aus Wollstoff / Woolen
ensemble, 1964/65
André Courrèges Haute Couture, Paris

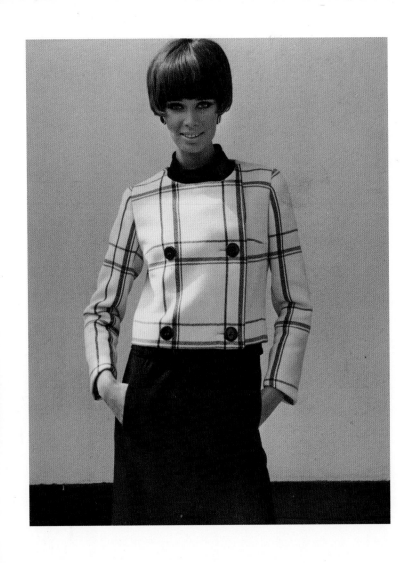

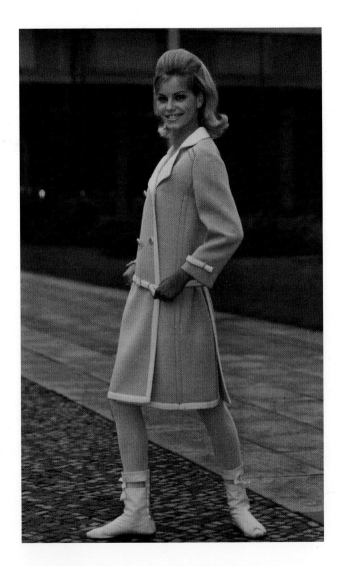

Jackenkleid aus Wollstoff / Woollen two-piece, 1967
Studio Dress, Berlin

Kamelhaarfarbener Mantel aus Wollstoff / Camel-colored wool
coat, 1966. Braasch, Berlin

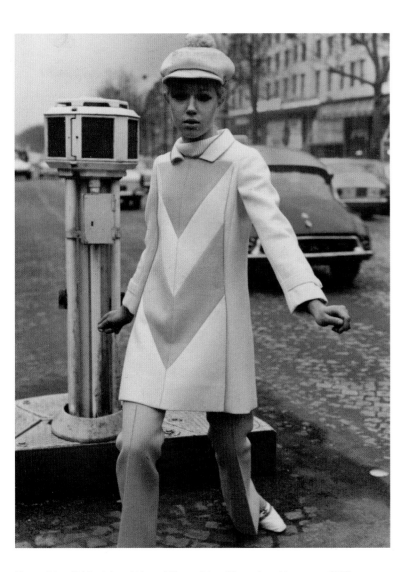

Ensemble mit Mantel und Hose / Ensemble with coat and trousers, 1966
Ted Lapidus, Paris

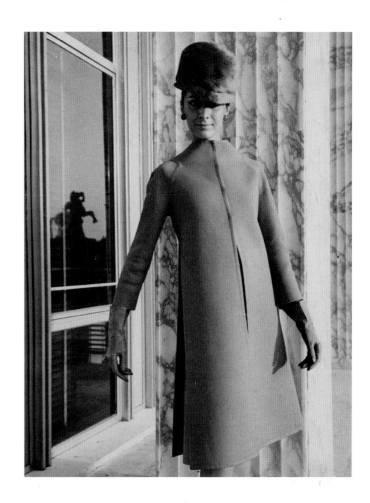

Ensemble aus Doubleface-Wollstoff / Double-face woollen ensemble, 1966
Fausto Sarli Alta Moda, Rom / Rome

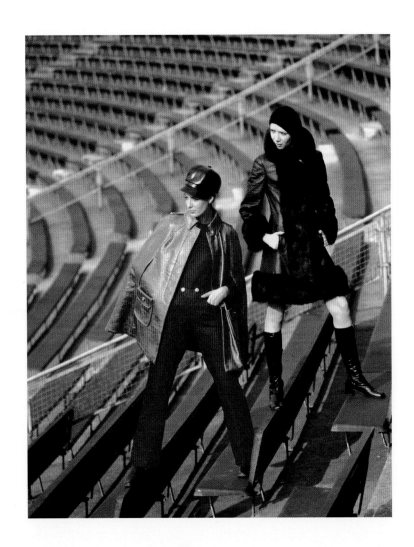

Modelle aus Kunst-Lackleder / Synthetic patent leather cape and jacket, 1969
Modelle: unbekannt / Designs: unknown

Sonnenbrille aus Metall / Metal sunglasses, 1967
Modell: unbekannt / Design: unknown

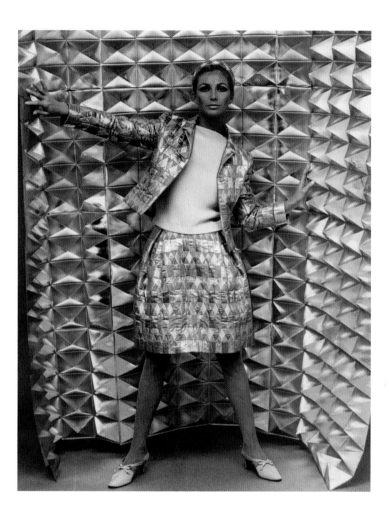

Cocktailkostüm aus Matelassé-Lamé / Matelassé lamé cocktail suit, 1966
Jeanne Lanvin, Paris

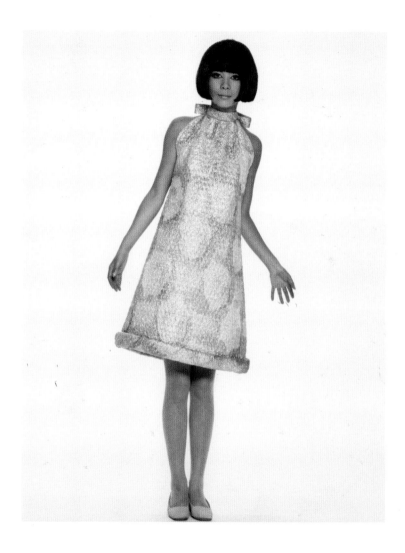

Cocktailkleid aus Tergal / Tergal cocktail dress, 1966
Pierre Cardin Haute Couture, Paris

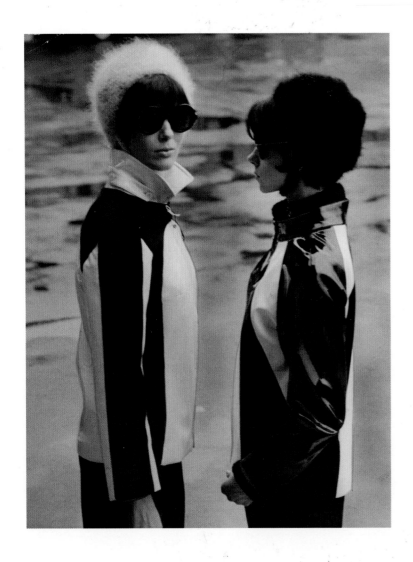

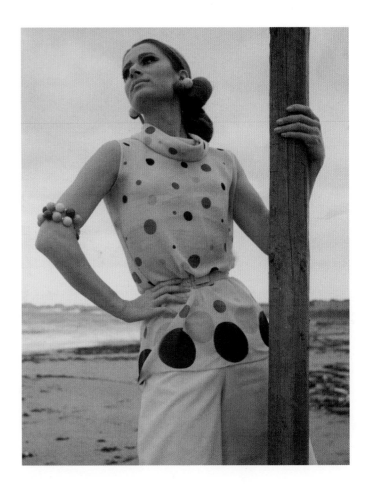

Schwarz-weiße Sportensembles / Black and white sports ensembles, 1966
Hauser, Paris

Weißer Strandanzug aus Seidenflor / White silk pile beach suit, 1967
Design: Eguzquiza

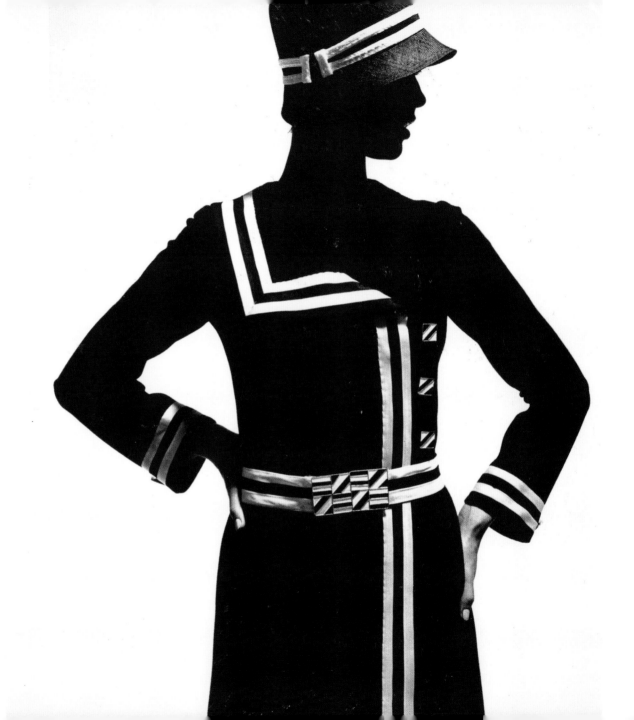

Schwarz-weißer Mantel / Black and
white coat, 1966. Lend, Paris

Hosen – Hosen – Hosen

„Hosen am Morgen, Hosen am Abend. Hosen auf der Reise, für Freizeit und Sport. Hosen in der Stadt. Hosen für große und kleine Feste", so titelte die Zeitschrift *Constanze* 1969 und fasste damit den Siegeszug der Frauenhosen prägnant zusammen.

Bereits seit Beginn der 1960er Jahre trugen die amerikanisch geprägten Teenager und jungen Frauen verschiedene Hosenarten in der Freizeit, beim Sport und auf Reisen. Im städtischen Modebild galten Hosen jedoch weiterhin als unpassend. Um dem weit verbreiteten Vorwurf der Vermännlichung der Frauen Einhalt zu gebieten, wurden die meisten Frauenhosen mit femininen Details angeboten: seitlicher Verschluss, körperbetonter Schnitt, und nur bis zum Knie oder zur Wade reichend. Allein die Jeans, als Protestkleidung der „Halbstarken", wurden Unisex getragen.

Nachdem der Pariser Couturier André Courrèges 1964 erstmalig seine Kollektion mit „Weltraumanzügen" gezeigt und damit gleichermaßen Protest wie Anerkennung erfahren hatte, begann auch die von Paris inspirierte Damenmode aller Länder das Thema Hosen mit wachsendem Erfolg zu vermarkten. Spätestens Ende 1967 waren Hosen in jeder internationalen Modekollektion vertreten: zwei- und dreiteilige Hosenanzüge, knappe Hosenröcke, sportliche Kniebund- und Kurzhosen, weite Abendhosen, sogenannte Palazzo-Pyjamas und romantische Hosenkombinationen sind nur einige der angebotenen Typen. Sie alle gewährten den Frauen eine deutlich höhere Bewegungsfreiheit, die durch neue elastische Materialien noch erhöht wurde. In der Modefotografie und -illustration wurden Hosenmodelle meistens in auffälligen Posen dargestellt: Die Frauen stehen extrem breitbeinig oder sie sitzen mit hochgezogenem oder angewinkelten Beinen. Es schien zu gelten, was Courrèges formuliert hatte: „Wer sich völlig frei bewegen will, muss Hosen tragen." AR

Trousers – trousers – trousers

'Trousers in the morning, trousers in the evening. Trousers for travelling in, casual trousers and trousers for sport. Trousers in town. Trousers at events – major events and small get-togethers.' So ran a heading in *Constanze* in 1969, summing up the undisputed triumph of trousers for women.

Right from the beginning of the Sixties, many teenage girls and young women, influenced by American styles, sported various kinds of trousers out of working or school hours, while playing sport and travelling. However, trousers on women remained a rare sight on the streets of most cities. To partially counteract the common criticism that women were being masculinized, most women's trousers included feminine details: side zips, figure-hugging cuts, often only reaching as far as the knee or calf. Only jeans, the protest clothing of choice for the new generation of 'rebels without a cause', were truly unisex.

After the Parisian couturier André Courrèges first showcased his collection of 'space suits' in 1964, which were greeted with an equal degree of protest and appreciation, the trend in women's fashion, as inspired by Paris, began to spread to all other western countries with an increasing degree of success. By 1967 by the latest, trousers could be seen in every international fashion collection: in the form of two and three-piece trousered suits, tight trouser skirts, sporty knickerbocker trousers and shorts, wide, billowy evening trousers, palazzo-pyjamas and romantic trouser combinations to name but a few. They all gave women a significant boast to their freedom of movement, which was increased still further by the new elastic materials used. In fashion photographs and illustrations, trousered models were usually depicted in striking poses: the women are seen standing with their feet conspicuously wide apart, or sitting with one leg crossed over the other or with both legs bent. Courrèges' words seemed to have rung true: 'Whoever wants to liberate themselves completely, has to wear trousers.' AR

Overall aus Crêpe / Crêpe jumpsuit, 1965
Foale & Tuffin, London

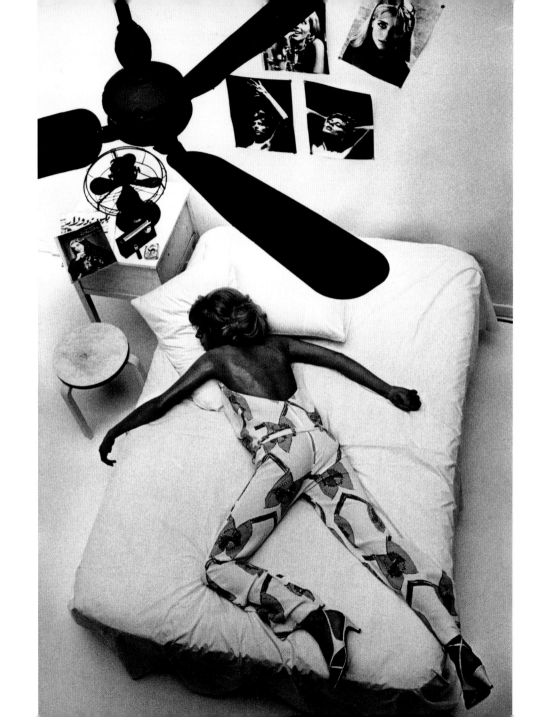

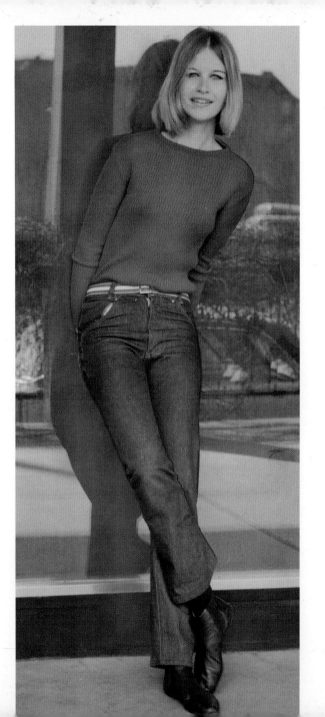

Jeans und Pullover / Jeans and pullover,
1964. Modell: unbekannt / Design: unknown

Pullover aus Merinowolle / Merino wool
pullover, 1967. Christian Dior Tricots, Paris

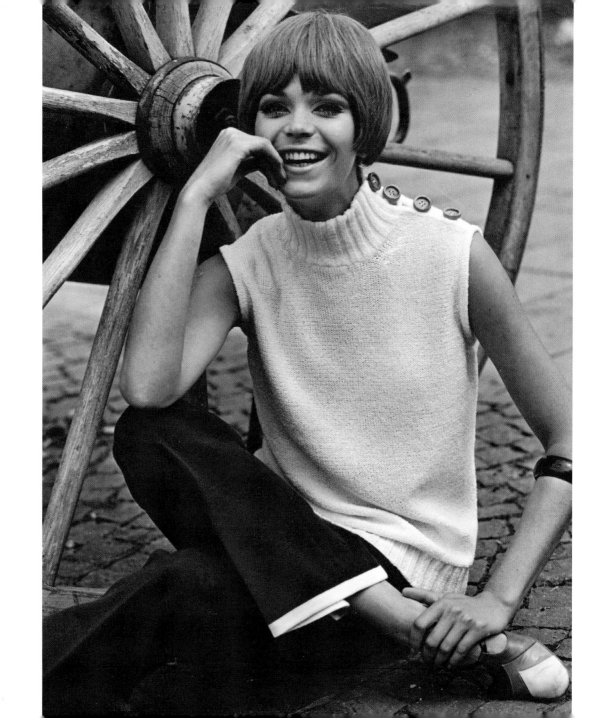

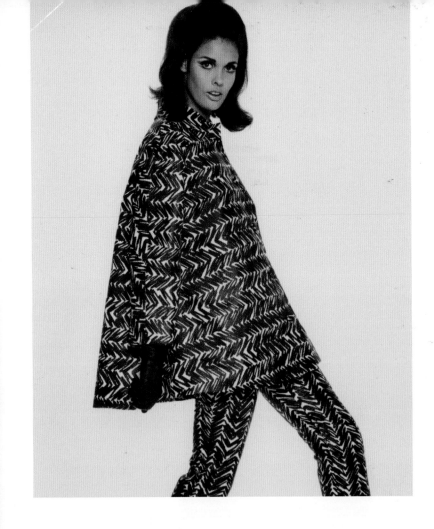

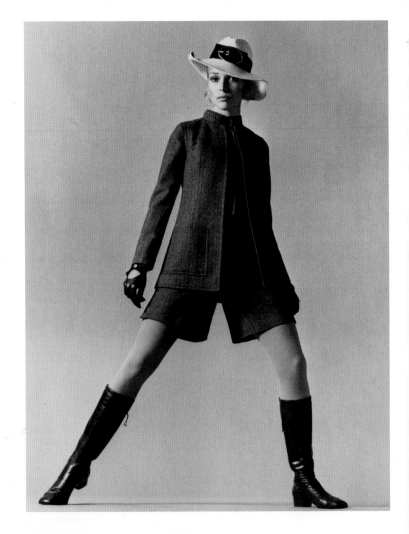

Blau-weißes Hosenensemble / Blue and white trouser ensemble, 1966
Hermès, Paris

Kastanienbraunes Hosenensemble / Chestnut trouser ensemble, 1968
Georges Rech, Paris

48

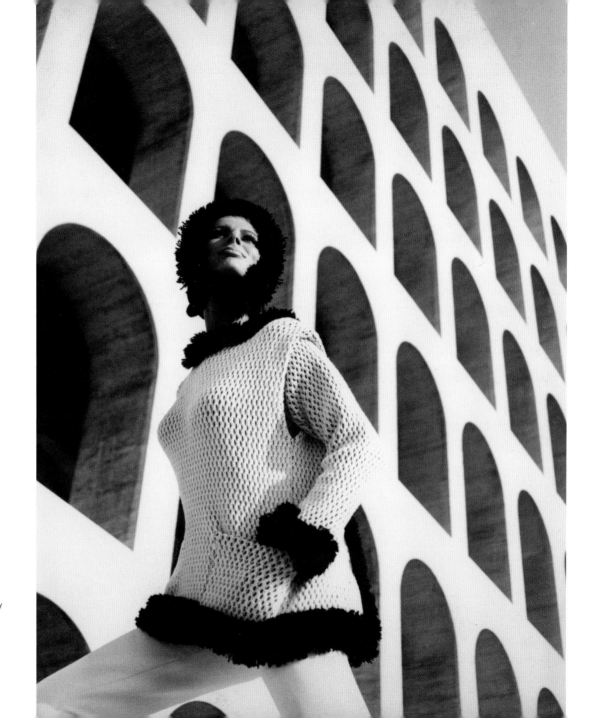

Après-Ski Pullover aus Acrylfaser /
Acrylic après-ski pullover, 1966
Simonetta Boutique, Paris

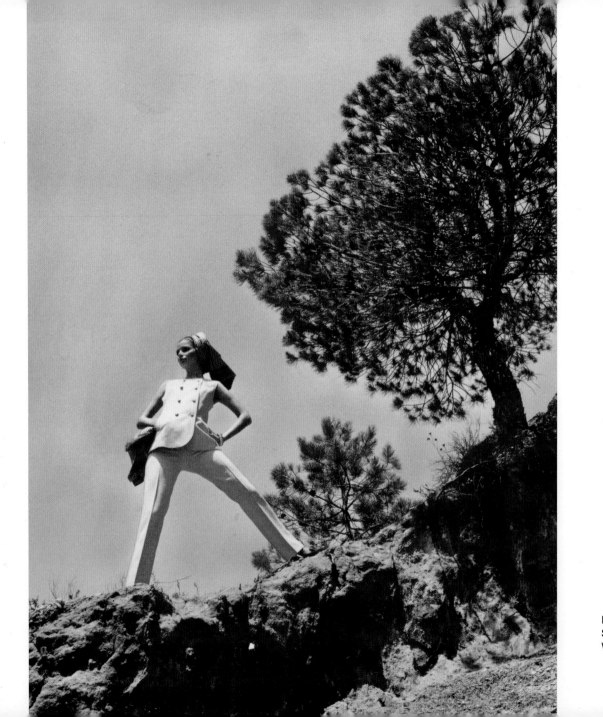

Hosenanzug aus Seidenleinen /
Silk-linen trouser suit, 1969
Willy Bogner, München / Munich

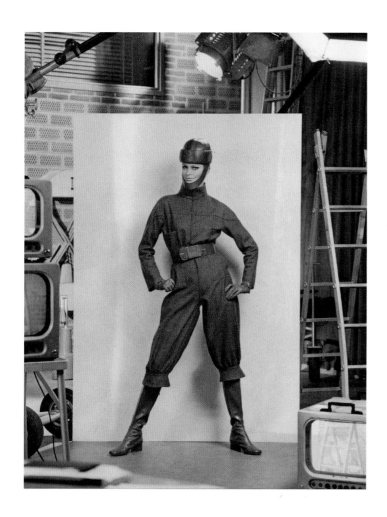

Jägergrüner Hosenanzug / Hunter-green trouser suit, 1968
Trevira Studio, Hattersheim

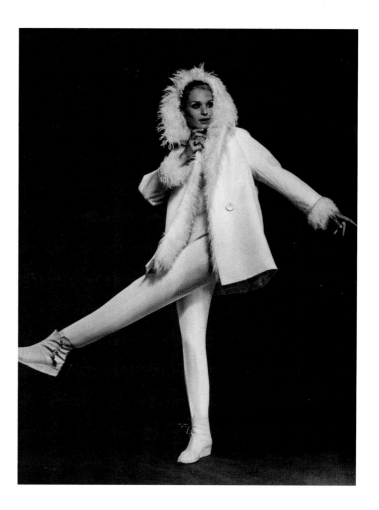

Après-Ski Anzug mit Lammfutter / Après-ski suit with lambswool lining,
1966. Hyacinthe Novak, Paris

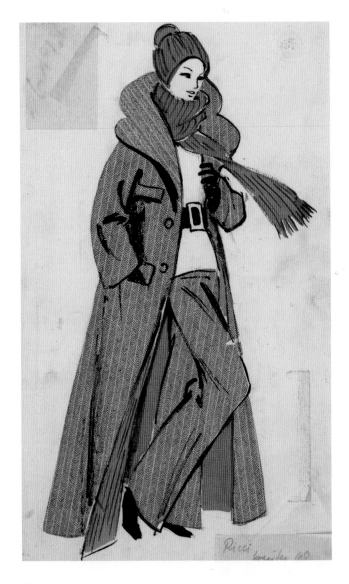

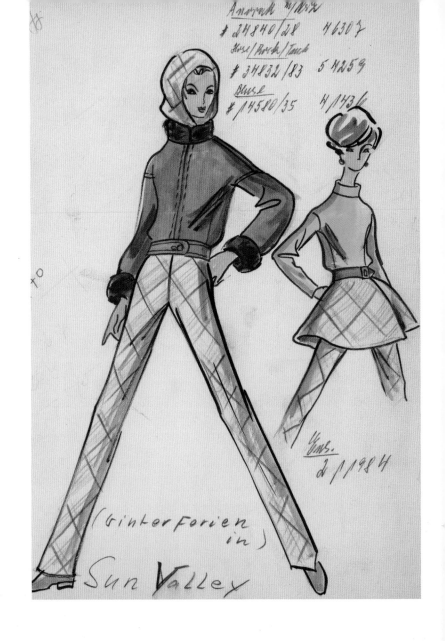

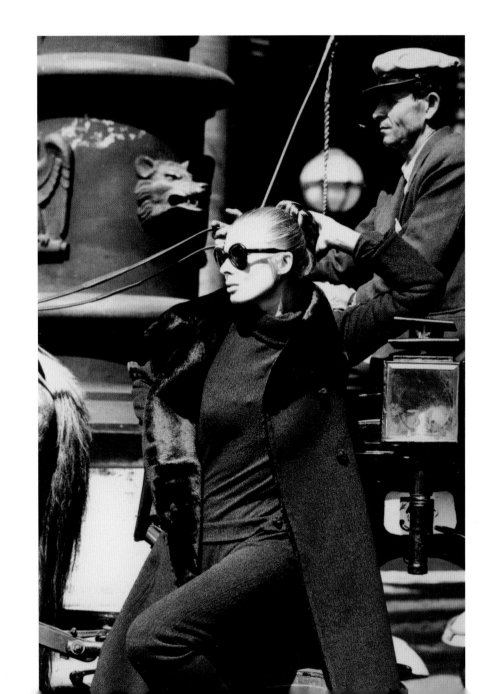

Sportensemble / Sports ensemble, 1968
Nina Ricci, Paris

Entwurf für ein Après-Ski Ensemble /
Design for an après-ski ensemble, 1969
Uli Richter, Berlin

Abendensemble aus Boucléjersey /
Bouclé jersey evening ensemble, 1966
Irene Galitzine Alta Moda, Rom / Rome

Blumenkinder: Romantik und Folklore

Die Zeitschrift *Constanze* schrieb im November 1965 über die neuesten Winterkleider: „Noch ist der Wettkampf Romantik gegen Geometrie nicht entschieden" und meinte damit die parallelen Trends von Nostalgie-Mode und minimalistischer Mode à la Mary Quant oder im Courrèges-Stil. Der Romantik-Look zeichnete sich durch verspielte, sehr weibliche Retro-Elemente aus: Kleidchen mit Blumenmustern und Pagodenärmeln, durchbrochene Spitzen, Perlenstickereien, Häkelmützen, Rüschenblusen und mit Pailletten besetzte Strickkleider. Als 1965 das Liebesdrama *Doktor Schiwago* in die Kinos kam, entstand zudem der Trend nostalgischer Pelzmode im Stil des frühen 20. Jahrhunderts.

Während London und Paris für die kommerzielle Mode der 1960er Jahre stilbildend waren, entwickelte sich in San Francisco die „Anti-Mode" der sogenannten Blumenkinder, die gegen gesellschaftliche Konventionen, Kapitalismus und den Vietnamkrieg protestierten. Auf der Suche nach spiritueller Erleuchtung und alternativen Lebensentwürfen brachten die Hippies von ihren Reisen südamerikanische Ponchos, Indienhemden, Afghanenmäntel, exotische Kaftane und Wickelkleider sowie bestickte Bauernblusen mit. Die daheim gebliebenen Individualisten hingegen entwickelten eigene kreative Fähigkeiten: In Heimarbeit färbten sie Baumwollkleidung nach indonesischen Batiktechniken, flochten Gürtel aus Lederfransen und bemalten oder bestickten ihre Jeans mit Friedenszeichen und Regenbögen. Im Zuge dieser „Do-it-yourself"-Bewegung erfreuten sich selbst gestrickte und gehäkelte Kleider, Mützen und Westen großer Beliebtheit.

Nach dem „Summer of Love" 1967 wurde die Hippie-Mode von der Industrie aufgegriffen und weltweit kommerzialisiert. Farbenfrohe Jeans mit Blumen- und Patchwork-Applikationen, bestickte Ethno-Kleidung, Kopftücher und bunt eingefärbte Pelze waren nun massenhaft in Boutiquen erhältlich. Sogar der puristische Couturier André Courrèges ließ sich 1967 von der „Flower-Power" mitreißen, indem er seine streng geometrischen Entwürfe mit runden Blütenblättern schmückte. HR

The Flower Children: Romanticism and Folklore

In November 1965, the magazine *Constanze* wrote on the latest winter dresses: 'The contest between romanticism and geometry is as yet undecided.' What this passage refers to are the two parallel trends of nostalgic fashion on the one hand, and minimalist fashion as designed by Mary Quant or Courrèges on the other. The romantic look was characterized by playful retro elements and a very feminine quality: little flower-patterned dresses with pagoda sleeves, sophisticated lace, pearl embroidery, crochet hats, ruched blouses and sequined knitted dresses. Additionally, when the dramatic romance of *Doctor Zhivago* hit the cinemas in 1965, fashion responded with a nostalgic trend for furs in early 20th century style.

While London and Paris were formative influences on the style of commercial fashion in the Sixties, San Francisco saw the development of an 'anti-fashion' sported by the 'flower children', who defined themselves through their protest against social conventions, capitalism and the Vietnam War. Searching for spiritual enlightenment and alternative ways of living, the hippies often travelled abroad, bringing back with them South American ponchos, Indian shirts, Afghan coats, exotic kaftans and wrap dresses, as well as embroidered peasant blouses. Meanwhile, individualists who had stayed at home developed their own creative skills: in their own homes, they dyed cotton garments by hand, using Indonesian batik techniques, plaited belts from leather straps and painted or embroidered their jeans with peace symbols and rainbows. As part of this 'DIY movement', self-knitted and self-crocheted dresses, hats and waistcoats enjoyed great popularity.

After the 1967 'Summer of Love', hippie fashion was taken up by the fashion industry and commercialized throughout the world. Colorful jeans with flower and patchwork appliqués, embroidered ethnic garments, headscarves and furs dyed in all colors were now available in great quantities in the shops. Even the purist couturier André Courrèges succumbed to the 1967 'flower power' and adorned his strictly geometric designs with round petals. HR

Cocktailkleid mit St. Galler Spitze / Cocktail dress with St. Gallen lace, 1965
Schiesser, Radolfzell

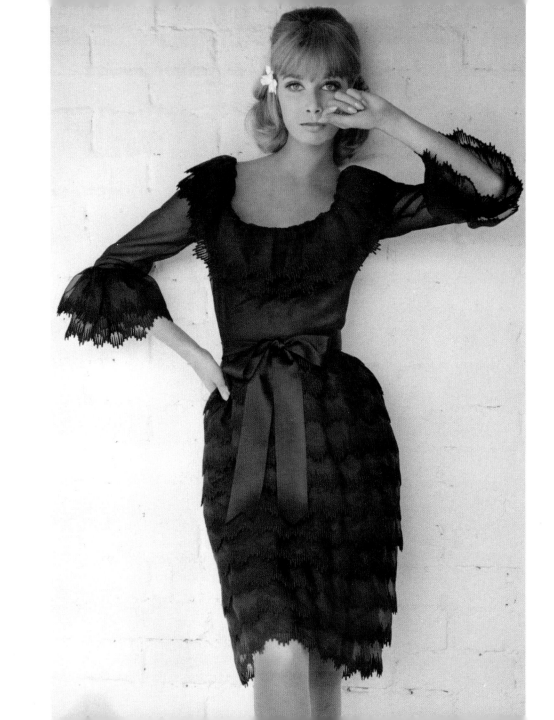

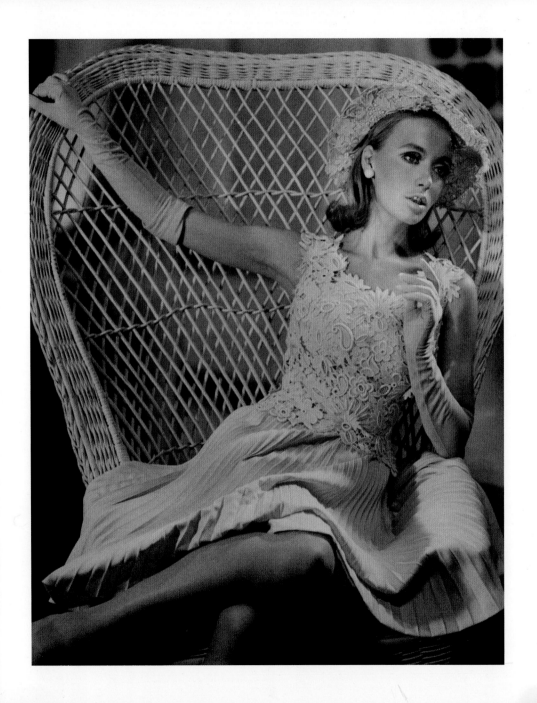

Sommerkleid mit plissiertem Rock / Summer
dress with pleated skirt, 1964
Uli Richter, Berlin

Nachmittagskleid aus Organza / Organza
afternoon dress, 1968
Ernesto Kuchling, Berlin

Cocktailkleid mit St. Galler Spitze / Cocktail
dress with St. Gallen lace, 1968
Irene Galitzine Alta Moda, Rom / Rome

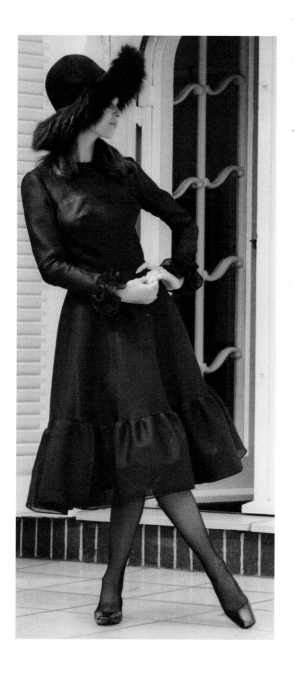

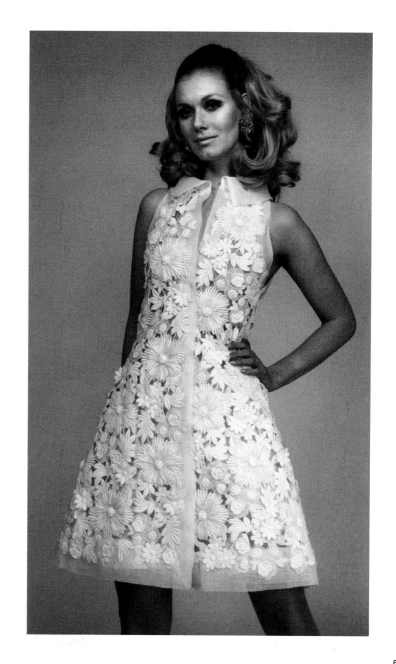

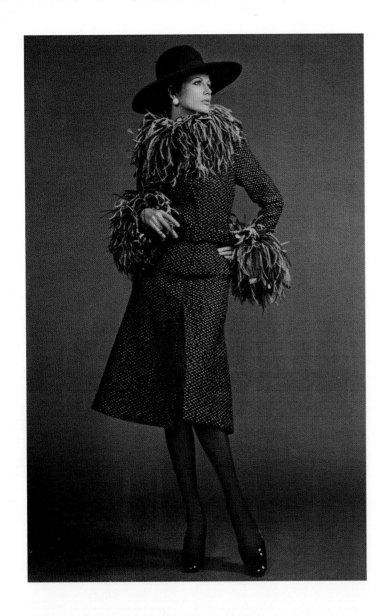

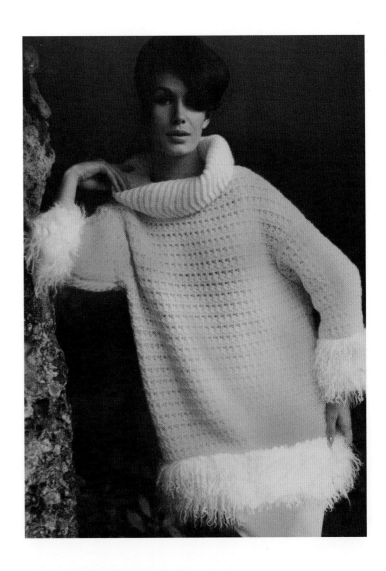

Tweedkostüm mit Straußenfedern / Tweed suit with ostrich feathers, 1968
Modell: unbekannt (Italien) / Design: unknown (Italy)

Après-Ski Pullover mit Lammfell / Après-ski pullover with lambskin, 1964
Veneziani Alta Moda, Mailand / Milan

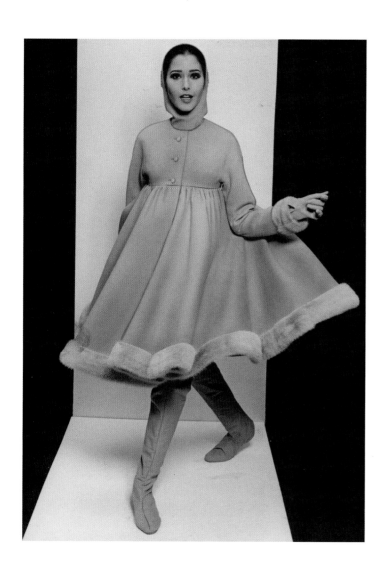

Bronzefarbener Abendmantel / Bronze evening coat, 1965
Modell: unbekannt / Design: unknown

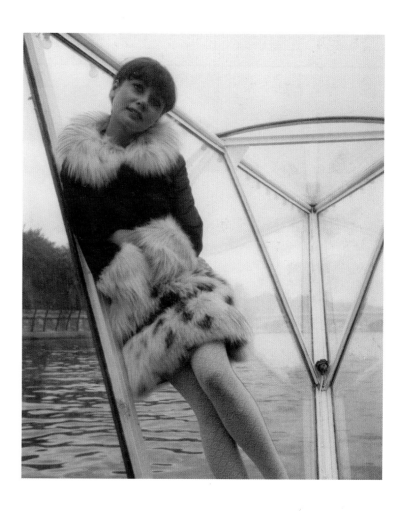

Mantel mit Luchsbesatz / Coat with lynx edging, 1967
Jacques Laurent, Paris

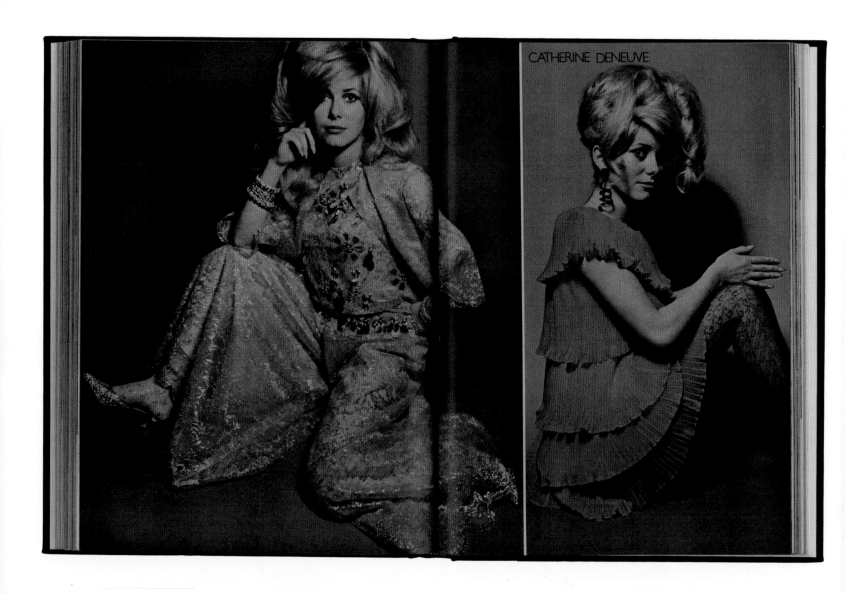

CATHERINE DENEUVE

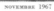
NOVEMBRE 1967

Extra-longue, la cape de berger en fourrure de laine, *ci-dessus*, fermée par des boucles dorées. Tiktiner chez Amie. Pantalon droit en fausse fourrure Crylor de Borg. V de V. Chéchia en mouton marron Jean-Charles Brosseau. Extra-courte, la pelisse en jersey rayé, *à droite*. Elle est doublée et bordée de peluche Crylor de Glénoit, et se ferme par des chaînes argent. Pierre d'Alby pour Dorothée Bis. Chéchia Jean-Charles Brosseau. Gants en cachemire Alexandre Savin. Cuissardes Carel.

LE MAROC
DES
SABLES

70

Vogue London
Dezember / December 1965

Vogue Paris
November 1967

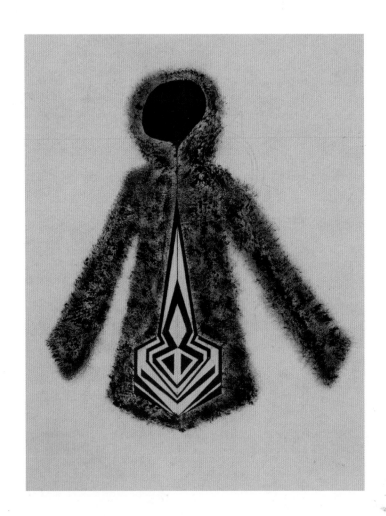

Entwürfe für einen Poncho / Design for a poncho, um / around 1969
Lette Verein Berlin

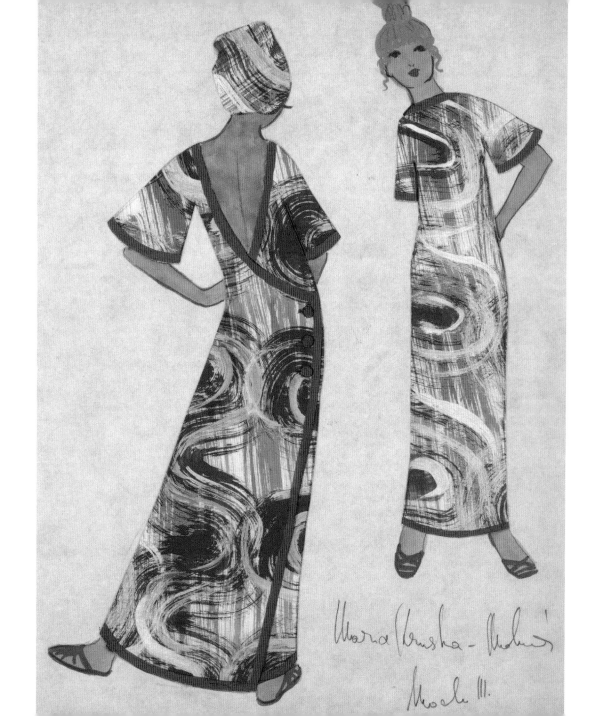

Entwurf für ein Wickelkleid / Design
for a wrap dress, um / around 1969
Lette Verein Berlin

Beautiful heads:
Frisuren, Make-up und Hüte

In den frühen 1960er Jahren galt der „Cleopatra-Look", inspiriert vom gleichnamigen Film mit Elizabeth Taylor in der Titelrolle, als das Schönheitsideal der Damen. Dazu gehörten schwarzes, glattes Haar, ein seitlich verlängerter, das Auge umrahmender Lidstrich, stark getuschte Wimpern, blauer Lidschatten sowie rote Lippen. Das Haar trug die elegante Dame mit Hilfe von Haarteilen aufgetürmt zu einer Hochfrisur à la Farah Diba oder als toupierten Pagenkopf mit schwungvoll eingedrehten Spitzen.

Jackie Kennedy machte den am Hinterkopf festgesteckten Pillbox-Hut populär. Ladylike waren auch kugelförmige, voluminöse Kappen aus Nerz oder Waschbär, mit denen sich eine imposante Silhouette des Kopfes erzielen ließ. Als Kontrast zu diesem damenhaften Look entwickelte sich ab 1964 der jugendliche Trend zu kurzem Haar. Besonders gern getragen wurde der von Vidal Sassoon kreierte „Five Point Cut" mit glattem Pony und scharfkantigen Spitzen vor und hinter den Ohren. Bei allen Frauen beliebt waren preisgünstige Perücken als sogenannte Zweitfrisur.

Modedesigner boten von nun an preiswerte Kosmetik für eine junge Zielgruppe an. Für diese Generation herrschte von 1964 bis 1966 die „No-Lips"-Ära, mit dezent hellen Lippenstiften. Schwerpunkt des Make-ups waren die Augen, die mit weißem Lidschatten, dunklem Eyeliner und großzügig getuschten – oder falschen – Wimpern in Szene gesetzt wurden. Ab 1966 waren von der Pop-Art inspirierte, knallige Farben sowohl für Augen als auch Lippen en vogue. Einige Modeschöpfer stellten Kunststoffhelme und Hüte wie aus der Raumfahrt vor. Die tragbare Variante der Weltraumhelme waren hohe, Schutzhelm-artige Bobby-Caps. Junge Frauen trugen zudem eng anliegende, unter dem Kinn gebundene Strickhauben sowie Basken- und Schirmmützen. Im Zuge der Hippie-Bewegung kamen große Schlapphüte, Stirnbänder und geblümte Kopftücher in Mode. Die Blumenkinder trugen die langen Haare in offenen Locken fallend oder mit einer Schleife im Nacken zusammengebunden. Auch das Make-up wurde um 1968 vorübergehend sehr natürlich. HR

Beautiful Heads:
Hair Cuts, Make-Up and Hats

In the early Sixties, the 'Cleopatra look', inspired by the film 'Cleopatra' starring Elizabeth Taylor, was considered the ideal of beauty among women. This involved straight black hair, eyeliner applied all around the eye and elongated at the sides, heavy mascara, blue eye shadow and red lips. The elegant lady wore her hair supported by hair pieces, piled up into beehives and other big hairdos as modelled by Farah Diba, or in back-combed bobs with bold inward curls.

Jackie Kennedy popularized the pillbox hat pinned to the back of the head. There were also voluminous ball-shaped hats made from mink or raccoon, which lent the head an imposing silhouette. In contrast to this ladylike style, youthful hair fashion from around 1964 moved towards short cuts. The 'Five Point Cut' created by Vidal Sassoon, a hairstyle with a straight fringe and sharply cut edges both in front of and behind the ears, came to be all the rage. Popular among all women were affordable wigs, the so-called 'second hairdo'.

Concurrent to this, fashion designers now offered inexpensive cosmetics for young people. For the young generation, the years between 1964 and 1966 were the 'no lips era' of discreet light-colored lipsticks. Make-up was dominated by the eyes, which were accentuated with white eye shadow, dark eyeliner, and generously mascaraed – or false – lashes. From 1966, bright colors inspired by pop art became fashionable for both eyes and lips. Some fashion designers brought out plastic helmets and hats reminiscent of space travel. A more wearable form of space helmet was the bobby cap, a high hat echoing the shape of a policeman's hat. Young women also wore tightly fitted knitted caps tied under the chin, as well as berets and peaked caps. With the hippie movement, large floppy hats, headbands and headscarves with flower patterns began to enjoy great popularity. Flower children wore their hair long, in loose natural waves and curls, or tied with a ribbon at the neck. Make-up, too, temporarily became very natural-looking around 1968. HR

Make-up für Pierre Balmain / Make-up for Pierre Balmain, 1965
Make-up: Guy Nicolet für / for Revlon

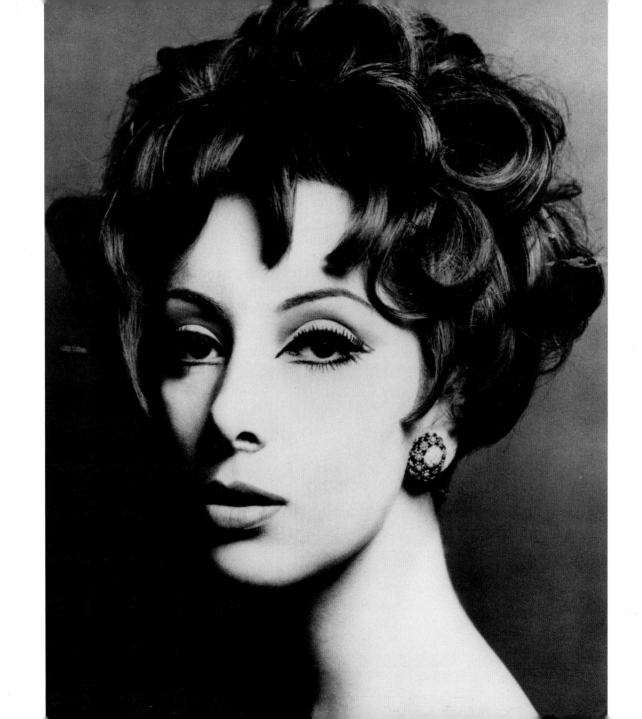

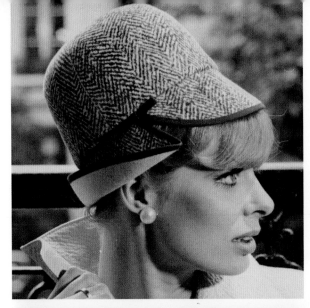

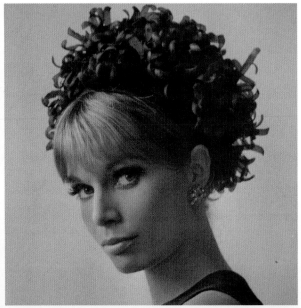

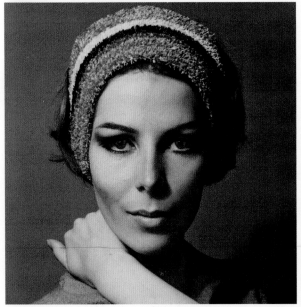

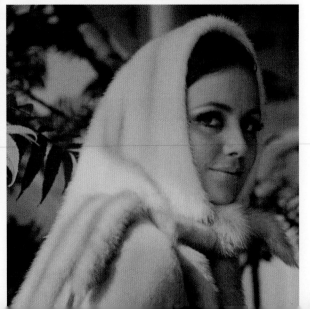

Helmhut aus Wollstoff / Woollen hat,
1965. Jacques Heim, Paris

Hut aus Stoffstreifen / Hat made out
of strips of fabric, 1965. Lilli Schark,
Berlin

Bandeau aus Bast / Bast bandeau,
1965. Horn, Berlin

Pastellfarbenes Nerzkopftuch / Pastel
mink headscarf, 1965. Schrank, Berlin

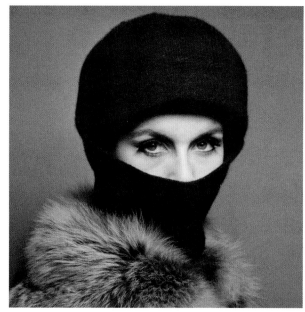

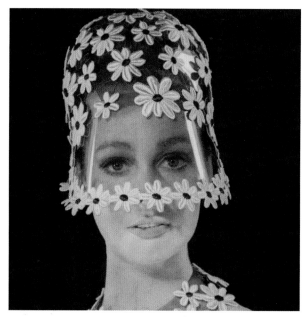

Kapuzenmütze aus Angorajersey / Angora jersey hooded cap, 1966 Pierre Balmain, Paris

Hut und Kragen im Astronautenlook / Astronaut style hat and collar, 1967 Blaise, Paris

Modischer Haarschnitt / Fashionable haircut, 1968. Frisur / Hairstyling: Alexandre, Paris. Make-up: Harriet Hubbard Ayer

Künstliche Wimpern / Artificial lashes, 1969. Make-up: Eylure, London

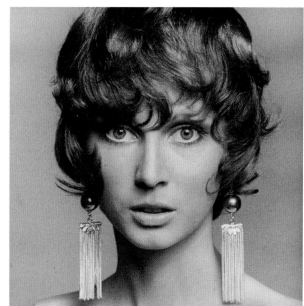

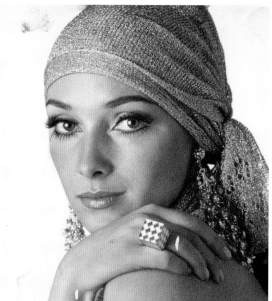

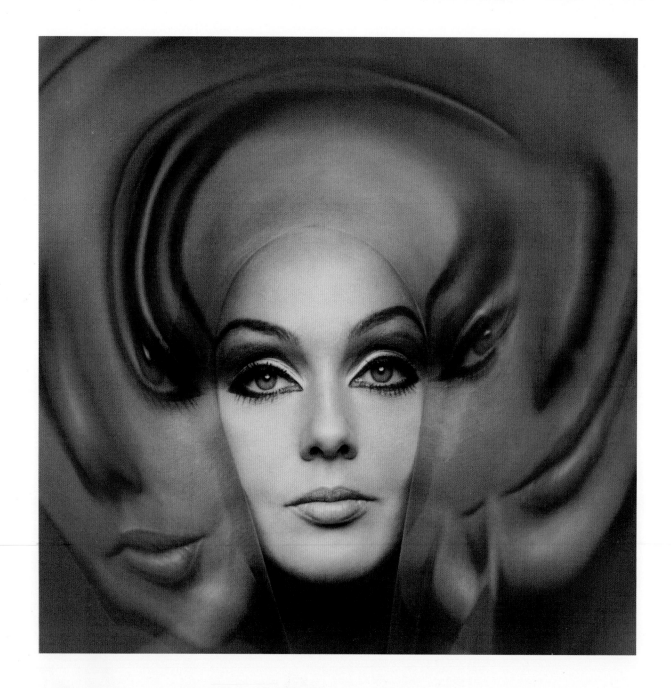

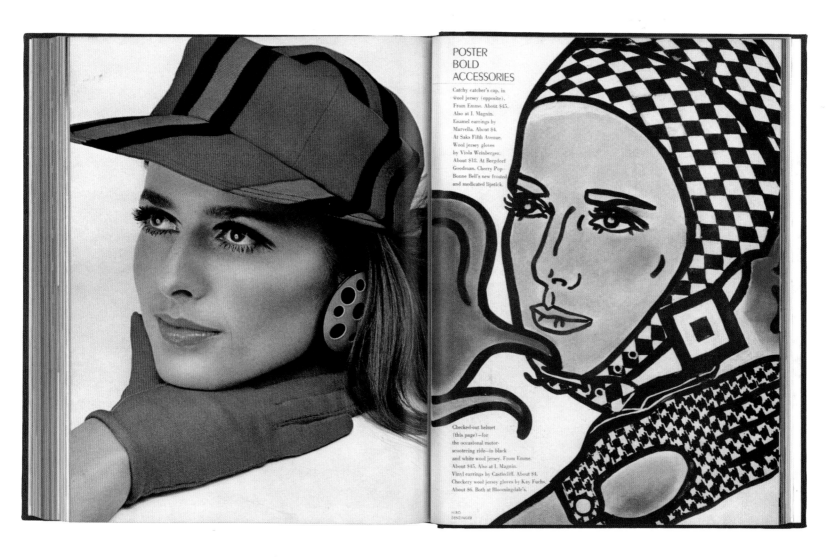

Make-up „Pink Frost" / 'Pink Frost' make-up, 1966
Make-up: Revlon

Harper's Bazaar New York, August 1966

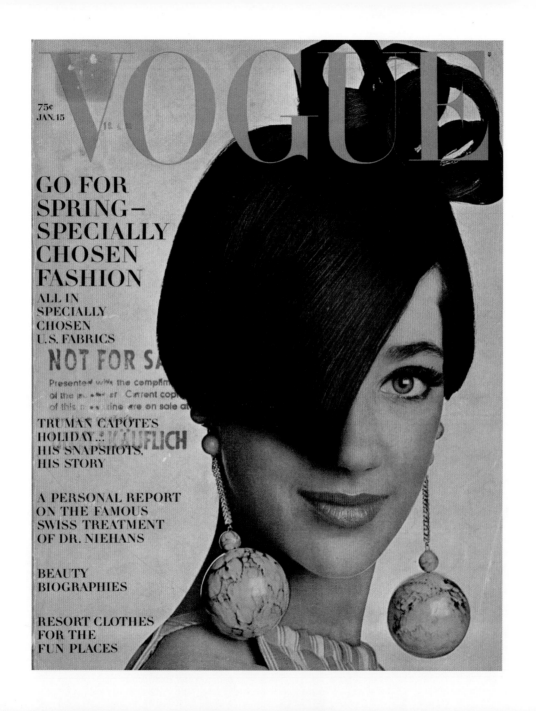

VOGUE

75¢
JAN.15

GO FOR
SPRING—
SPECIALLY
CHOSEN
FASHION
ALL IN
SPECIALLY
CHOSEN
U.S. FABRICS

NOT FOR SA
Presented with the compliments
of the publisher. Current copies
of this magazine are on sale at

TRUMAN CAPOTE'S
HOLIDAY…
HIS SNAPSHOTS,
HIS STORY

A PERSONAL REPORT
ON THE FAMOUS
SWISS TREATMENT
OF DR. NIEHANS

BEAUTY
BIOGRAPHIES

RESORT CLOTHES
FOR THE
FUN PLACES

Vogue New York
Januar / January 1966

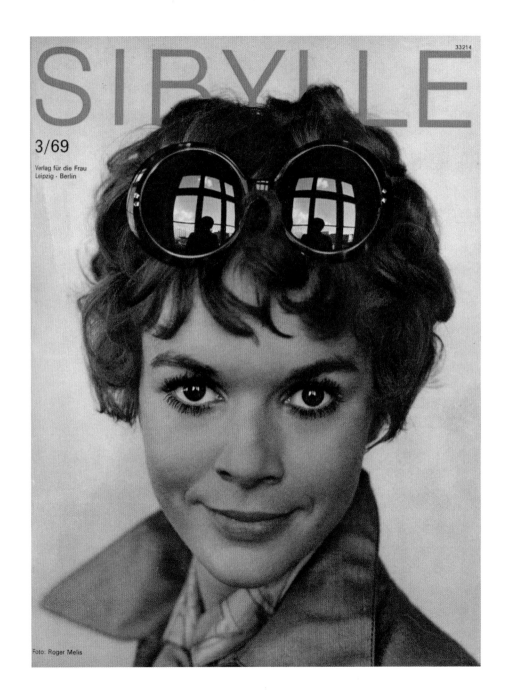

SIBYLLE

33214

3/69

Verlag für die Frau
Leipzig · Berlin

Foto: Roger Melis

Sibylle Berlin (DDR / GDR)
März / March 1969

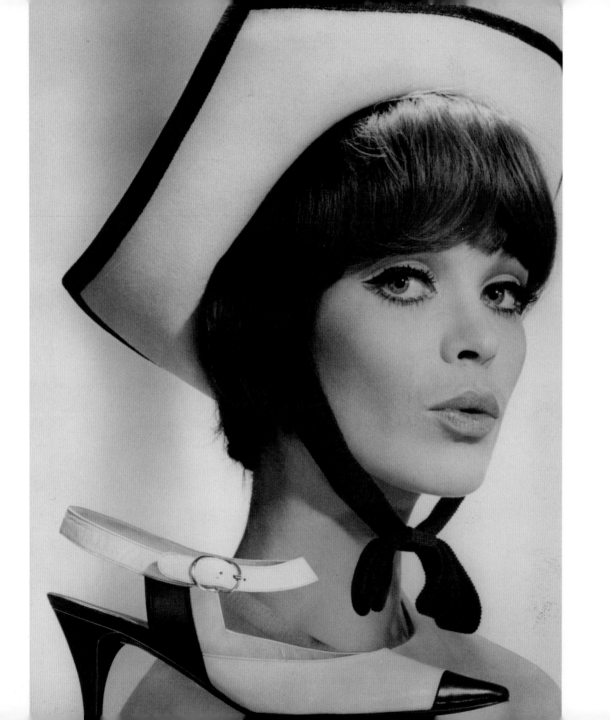

Hut und Schuhe à la Courrèges /
Hat and shoes à la Courrèges, 1966
Dorndorf, Zweibrücken

Schal mit Straußenfedern / Ostrich
feather scarf, 1966
Femme & Lida Ascher Boutique

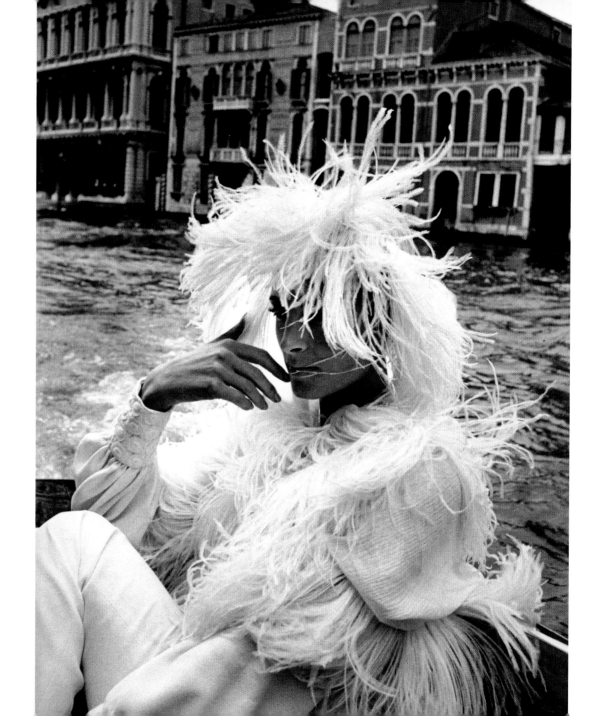

Body Fashion:
Strumpfhosen, Bademode, Wäsche

1960 wurde erstmals der „Strumpf bis zur Taille" vorgestellt, der sich ab 1964, zeitgleich mit der Mini-Mode, als Strumpfhose etablierte und schnell die bis dahin üblichen Strümpfe mit Strumpfbandgürtel verdrängte. Die neuen Beinkleider präsentierten sich in vielen Variationen: von Netz-, Spitzen- und Häkelstrumpfhosen in knalligen Farben und Mustern über schlichte unifarbene Nylons bis hin zu Lurex- und Goldlaméstrumpfhosen.

Bademoden und Strandensembles wiesen großflächige Muster aller Art auf, der Materialvielfalt waren keinerlei Grenzen gesetzt: Bikinis aus Frottee, Badeanzüge aus Klöppelspitze und Pareos aus Baumwollsatin waren an den internationalen Stränden keine Seltenheit. Schon zu Beginn der 1960er Jahre zeichnete sich der Trend zu Cut-Out-Badeanzügen mit tiefen Ausschnitten an den Seitenpartien ab. Auch der Bikini, seit 1946 existierend, setzte sich im Zuge des freieren Körperempfindens der Sechziger durch. Der gebürtige Wiener Rudi Gernreich erregte 1964 internationales Aufsehen mit dem von ihm kreierten „Monokini" aus schwarzem Wollstrick, eine bis zum Rippenbogen hoch geschnittene Badehose mit zwei schmalen, zwischen den Brüsten entlang führenden und über die Schultern gestreiften Trägern. Der Monokini setzte sich zwar keineswegs durch, bereitete jedoch den Weg für den ebenfalls von Gernreich entworfenen, unversteiften und transparenten „NO BRA" („Kein-BH"), aus thermoplastisch vorgeformtem, durchsichtigem Stretchmaterial gefertigt. Während in Deutschland noch für BHs mit Jersey-Einsätzen und Figur formende Miederhöschen geworben wurde, präsentierte Yves Saint Laurent 1968 den Transparent-Look, bei dem durchsichtige Blusen und Kleider ohne BH zu sehen waren.

1965 entwarf Mary Quant ihre erste Wäschekollektion in Form von jugendlichen, schwarz-weißen Garnituren, bei denen BHs und Miederhöschen mit Gänseblümchenmotiven untereinander austauschbar waren. Die Frauenwäsche der „High Sixties" war zwar größtenteils nicht weniger formend als vorher, sie ließ allerdings den Körper so androgyn und flach wie möglich erscheinen. HR

Body Fashion:
Tights, Swimwear, Lingerie

In 1960, the 'stocking that extends to the waist' was unveiled for the first time and from 1964 onwards the new pantihose or tights soon overtook the stockings and garters commonly worn until then, in a development that ran parallel to the rise of the miniskirt and mini dress. The new legwear came in many forms: from net, lace and crochet tights in brash colors and patterns, to simple monochrome nylons and even Lurex and gold lamé tights.

Bathing fashions and beach ensembles displayed all kinds of extensive patterning; there seemed to be no limit to the diversity of material used: bikinis made of terry towelling, bathing suits made of bobbin lace and pareos made of sateen were a common sight on beaches around the world. Even at the start of the Sixties, there was a palpable move towards cut-out bathing suits with deep cuts at the sides. The bikini, which had been around since 1946, also came into its own as a result of the greater willingness to flaunt the body. Rudi Gernreich caused international sensation with his black woolknit 'monokini', a one-piece bathing costume with only two thin straps running between the breasts and over the shoulders. It was far from being a commercial success, but it did pave the way for the unstiffened and see-through 'No-Bra Bra', also designed by Gernreich, made from thermoplastically moulded, transparent stretch material. While bras with jersey inserts and figure-forming girdles were still being pushed in Germany, in 1968 Yves Saint Laurent unveiled the see-through look, in which see-through blouses and dresses were worn without bras underneath.

In 1965, Mary Quant designed her first lingerie collection in the form of youthful, black and white sets, in which bras and panties with daisy motifs could be combined and swapped with each other. Women's underwear of the High Sixties was, for the most part, no less sculpting than before, but it now had the effect of making the body appear as androgynous and flat as possible. HR

Strandensemble / Beach ensemble,
1968. Georgina Linhart, London

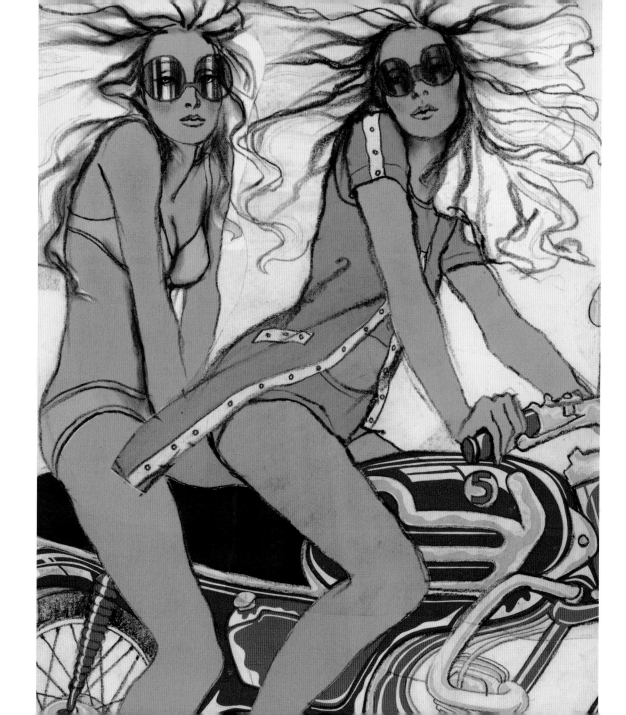

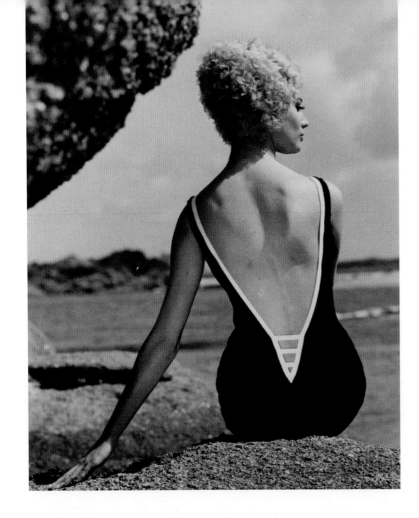

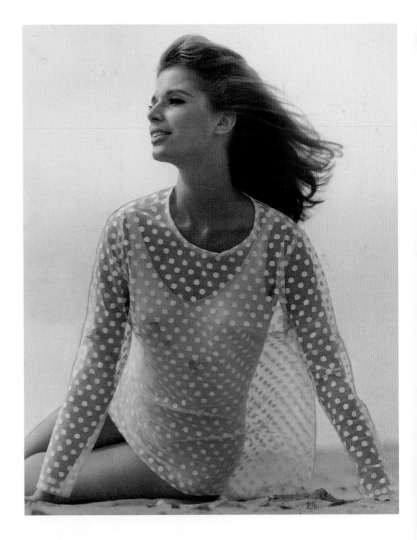

Schwarz-weißer Badeanzug / Black and white bathing suit, 1966
Mayogaine, Paris

Strandhemd und Badeanzug / Beach shirt and bathing suit, 1965
Uhli, Lippstadt

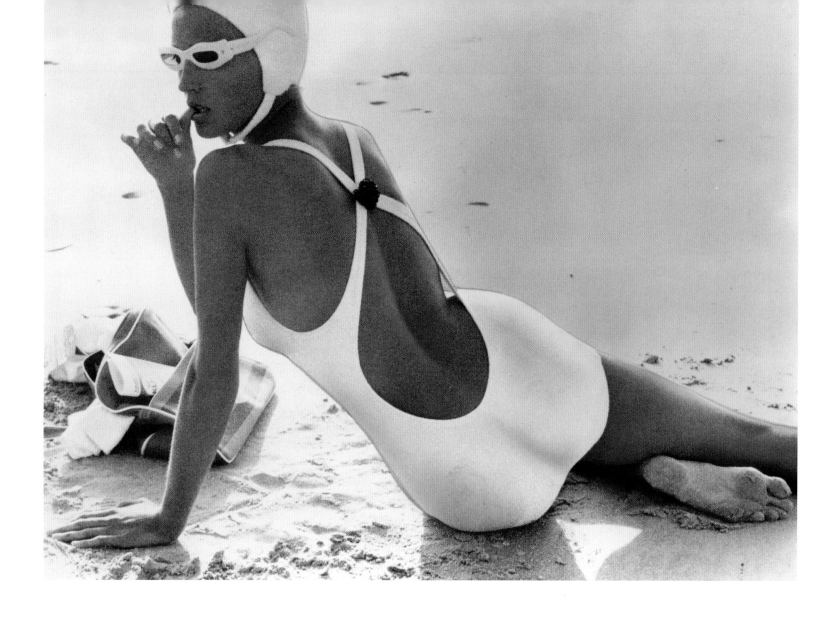

Heller Badeanzug / Light bathing suit, 1965
Triumph International, München / Munich

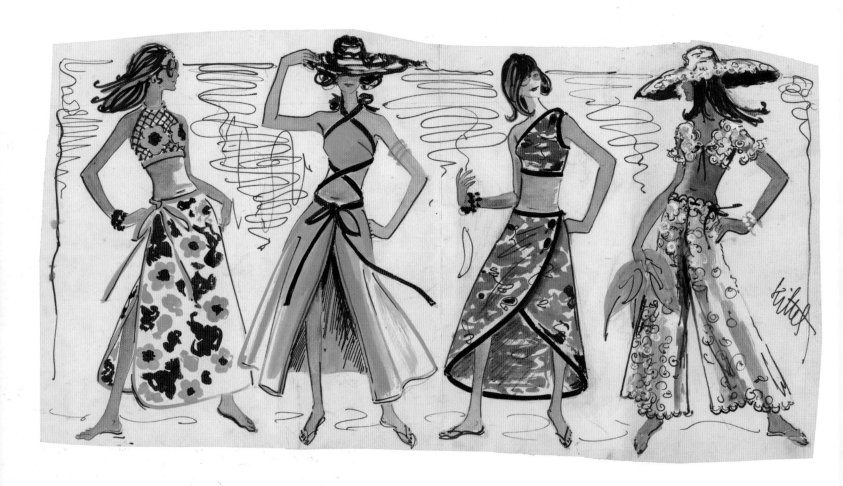

78

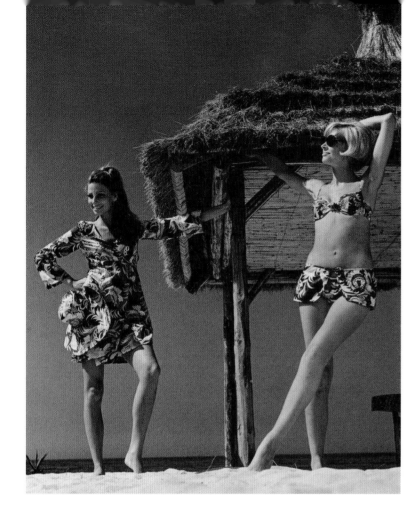

Strandanzüge / Beach outfits, um / around 1969
Modelle: unbekannt / Designs: unknown

Strandset aus Baumwollsatin / Sateen beach set, 1968
Felina, Mannheim

Bademantel aus Walkfrottee / Full terry cloth bathing gown, 1968
Egeria, Tübingen

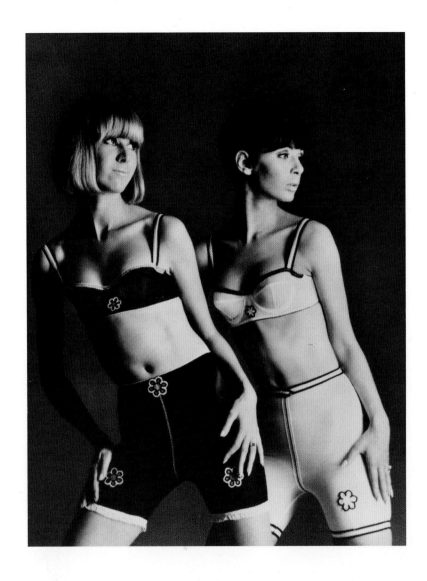

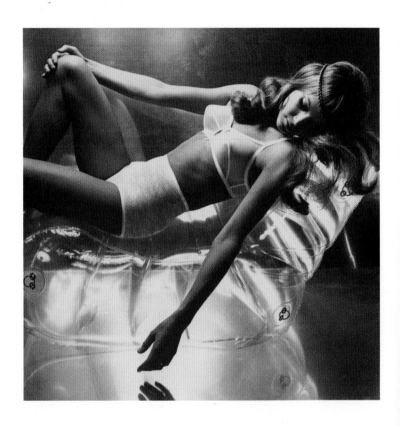

Unterwäsche-Sets / Underwear sets, 1965
Modelle / Design: Mary Quant, London

Transparent-BH und Spitzenhöschen/
See-through bra and lace slip, 1969
Triumph International, München / Munich

Twen München, August 1965

Nr. 8 August 1965 7. Jahr 2,– DM 1 H 6773 E

twen

**Schenken
Sie
Ihrem
Mann
eine
neue
Frau**

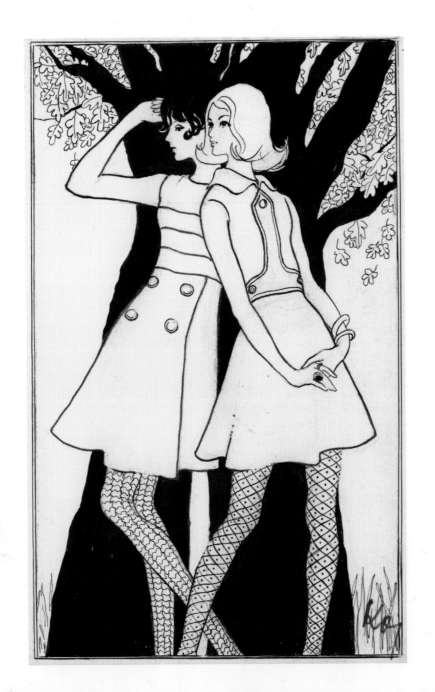

Junge Mode mit Strumpfhosen /
Young fashion with tights, o. J. /
n.d. Modelle: unbekannt / Designs:
unknown

Hudson Strumpfhosen / Hudson tights,
um / around 1969. Plakat / Poster

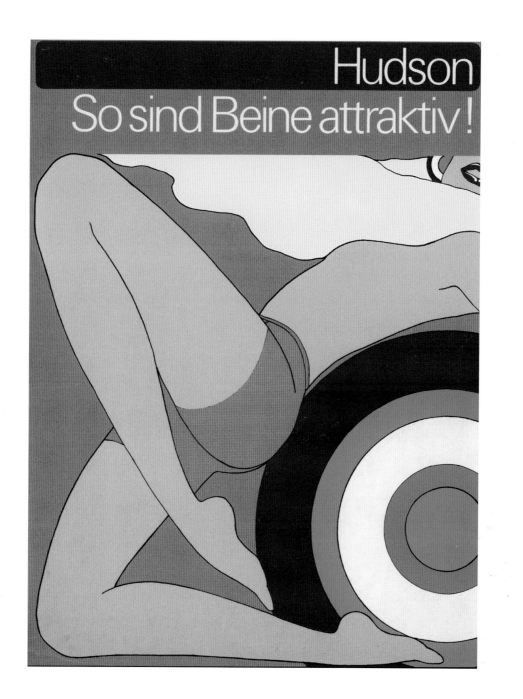

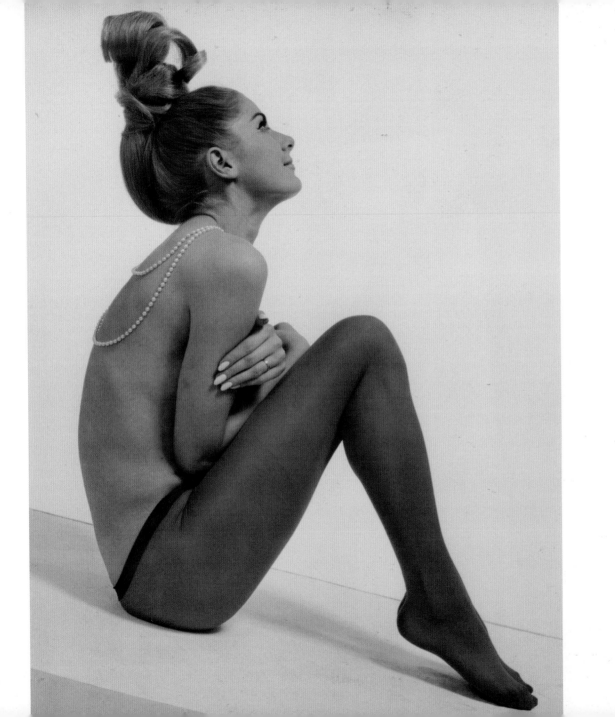

Feinstrumpfhose aus Agilon / Agilon
fine tights, o. J. / n.d. Design: Opal

Kollektionsübersicht / Collection
picture, 1968. Louis Féraud, Paris

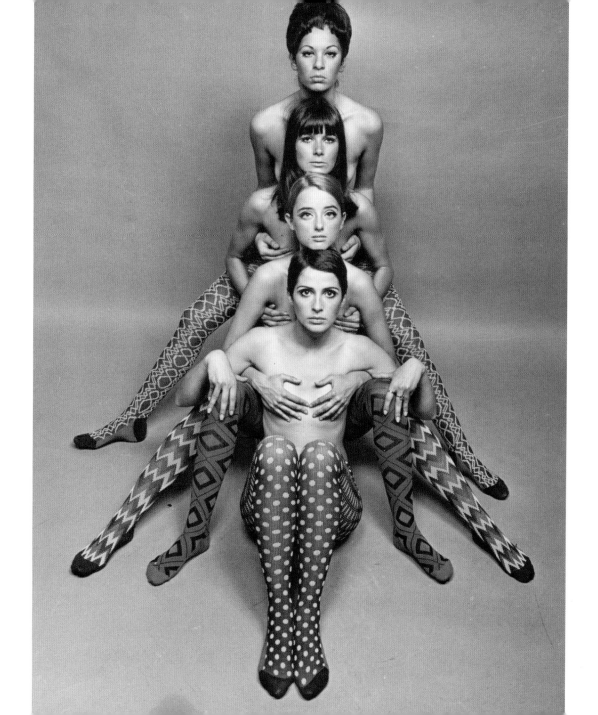

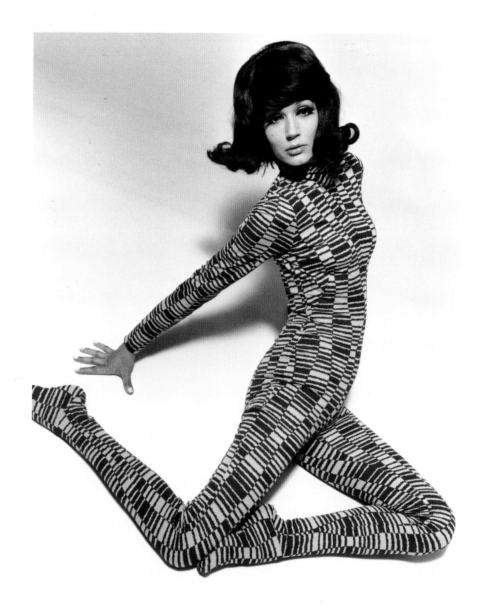

Strumpfhose / Tights, o. J. / n.d.
Louis Féraud, Paris

Silberfarbene Strumpfhose / Silver tights,
o. J. / n.d. Louis Féraud, Paris

Gemustertes Bodysuit / Patterned body
suit, 1966/67. Falke, Schmallenberg

Textildesign zwischen Fantasie und Geometrie

In kaum einer Epoche waren Stoffe so bunt und die Muster so vielfältig wie in den „High Sixties". Neben den klassischen Karos und Hahnentrittmustern tauchten 1963 Stoffmotive auf, die von der zeitgenössischen Kunst inspiriert waren. Die geometrisch-abstrakten Motive der Op(tical)-Art ergaben überraschende Flimmereffekte und perspektivische Illusionen, die vor den Augen verschwammen. Saint Laurent, Féraud und Courrèges waren einige der Designer, die sich dieses Stils bedienten. Der Pop(ular)-Art entlehnten die Designer Stoffdrucke in knalligen Farben, mit Szenen im Stil amerikanischer Comic-Strips sowie stilisierter, Porträts strahlender Filmstars. Yves Saint Laurent präsentierte 1965 seine „Mondrian-Kollektion" mit Jersey-kleidern, deren Farbflächen auf die Werke des konstruktivistischen Malers Piet Mondrian zurückzuführen waren.

Florale Motive gab es als romantische Allover-Prints oder als grafisch stilisierte Gänseblümchen à la Mary Quant. Ein anderes Thema waren Animal-Prints: die Palette reichte von Schlangen- über Zebra-Prints bis hin zu Dalmatiner-Mustern. Elegante Damen trugen Puccis Seidenjersey-Kleider mit psychedelischen Mustern, die ihren Ursprung in mittelalterlichen, stark abstrahierten Wappenbannern hatten. Auch die Hippie-Bewegung entdeckte die psychedelischen Muster für ihren nonkonformen Look. Zudem setzten die Blumenkinder auf exotische Muster wie Paisley und ornamental-folkloristische Fantasie-Motive. Das Motto der Textildesigner der „High Sixties" schien „größer, bunter, wilder" zu sein.

Für die geometrische Textilmusterung der 1960er Jahre spielten Courrèges und Cardin die entscheidende Rolle. Im November 1965 berichtete die Zeitschrift *Constanze*: „Die Geometrie hält Einzug in die Mode. [...] Geometrische Formen inspirierten nicht nur die Mo-deschöpfer zu einer neuen Silhouette, auch die Stoffmuster scheinen häufig mit Lineal und Winkelmesser entworfen worden zu sein. Ein Lieblingsmuster der Mode: das Schachbrettkaro – klar, grafisch und munter in kontrastreichen Farbspielen." Blockstreifen, riesengroße diagonal verlaufende Tupfen und kleine farbenfrohe Rhombenmotive waren weitere geometrische Muster. HR

Textile Design between Fantasy and Geometry

Hardly any other age has seen fabrics as colorful and patterns as diverse as the 'High Sixties'. From 1963, textile patterns inspired by contemporary art appeared side by side with the classic tartans and houndstooth checks. The abstract geometric motifs of optical art produced surprising flickering effects and illusions of perspective, creating a blurred vision. Saint Laurent, Féraud and Courrèges were among the designers employing such stylistic features. From pop art, textile designers borrowed gaudy colors and graphic motifs in the manner of American comic strips or stylized portraits of glossy film stars. In 1965, Yves Saint Laurent presented his 'Mondrian Collec-tion' of jersey dresses with monochrome color fields derived from the constructivist works of the painter Piet Mondrian.

Floral motifs remained en vogue, whether as romantic all-over prints or in abstracted form, as in the stylized daisies of Mary Quant and others. Another theme were animal prints. Here, the palette reached from snake and zebra prints to Dalmatian dog patterns. Elegant ladies wore Pucci's silk jersey dresses with psychedelic patterns originating in heavily abstracted medieval crests and flags. The hippie movement, too, discovered psychedelic patterns for its non-conformist look. The flower children also loved exotic patterns such as paisley and ornamental motifs inspired by folklore or their own imagination. The motto for 'High Sixties' textile designers seemed to be: 'larger, brighter, wilder'.

The designers Courrèges and Cardin played an important role in the development of geometric fabric patterns. In November 1965, the women's magazine *Constanze* reported: 'Geometry has arrived in fashion. [...] Geometric forms have inspired fashion designers not only to a new silhouette, but their fabric patterns, too, often seem to have been created with the aid of compass and straightedge. A favourite pattern in fashion: the chessboard check – clean, graphic and jolly in its contrast-rich color games.' Giant stripes, huge di-agonally arranged dots and small diamond motifs in all colors also belonged to the wide spectrum of geometric patterns. HR

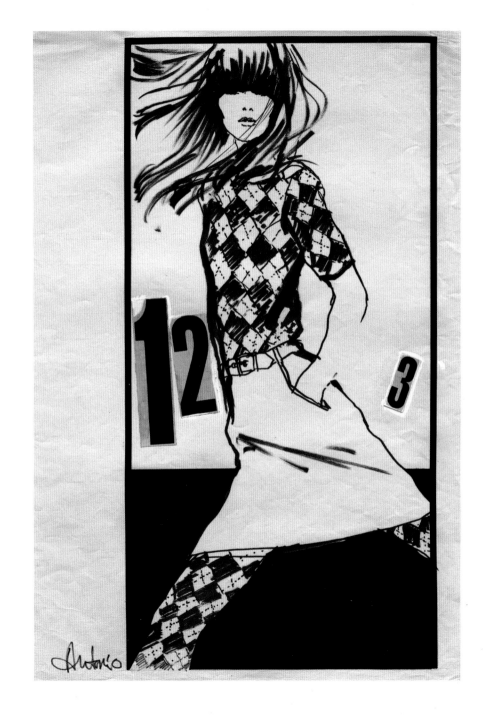

Pullover und Strumpfhose / Pullover
and tights, 1965. Burlington, London (?)

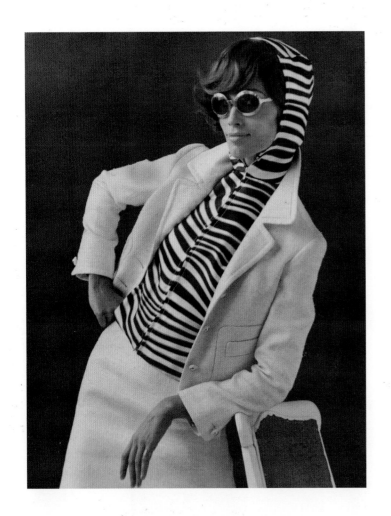

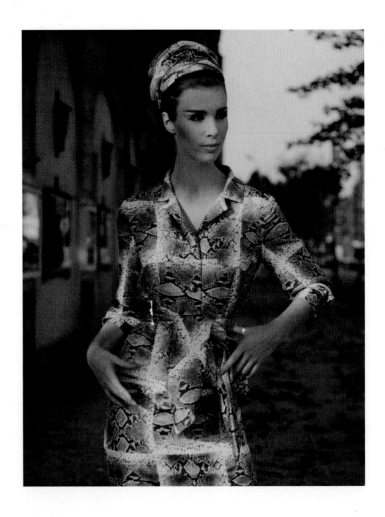

Kostüm mit Kapuzenbluse / Outfit with hooded blouse, 1969
Uli Richter, Berlin

Sommerkleid mit Schlangenprint / Snake-print summer dress, 1964
Uli Richter, Berlin

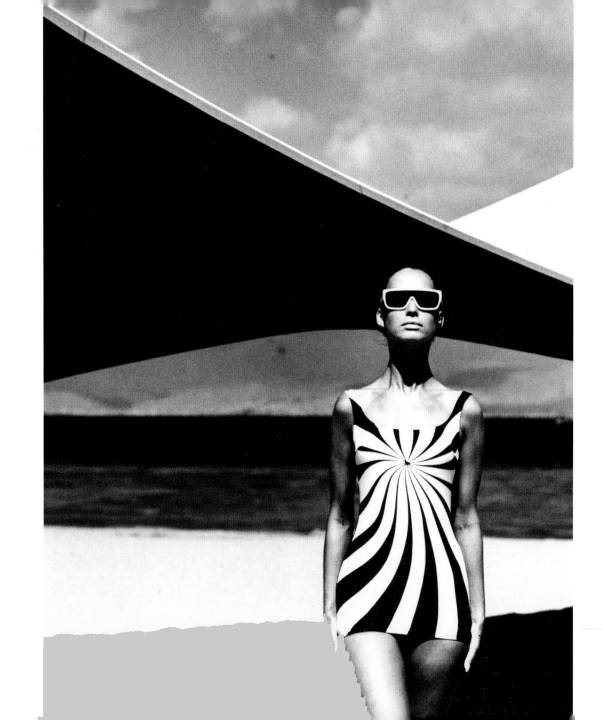

Op-Art Badeanzug / Op art bathing suit,
1966. Sinz

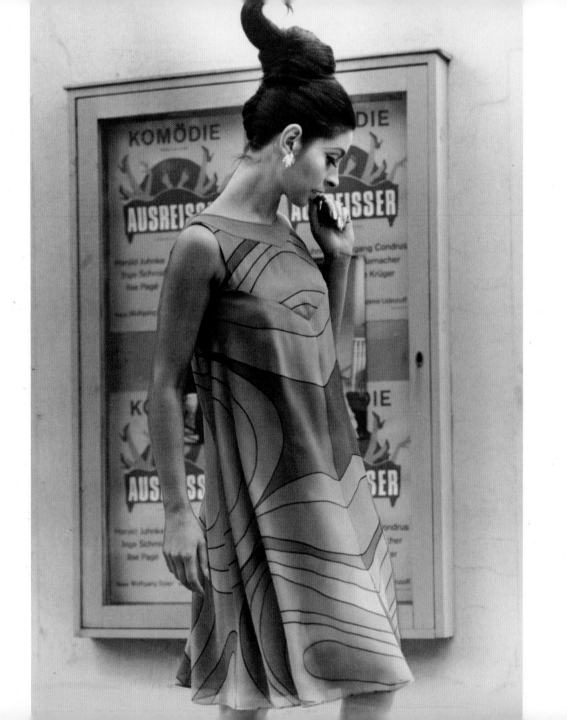

Sommer-Abendkleid aus Chiffon /
Chiffon summer evening dress, 1966
Staebe-Seger, Berlin

Harper's Bazaar New York,
Februar / February 1967

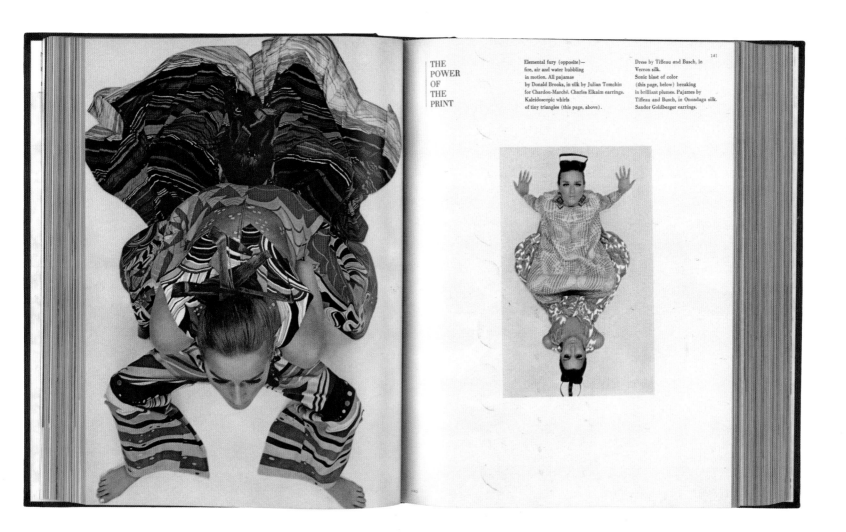

THE
POWER
OF
THE
PRINT

Elemental fury (opposite)—
fire, air and water bubbling
in motion. All pajamas
by Donald Brooks, in silk by Julian Tomchin
for Chardou-Marché. Charles Elkaim earrings.
Kaleidoscopic whirls
of tiny triangles (this page, above).

Dress by Tiffeau and Busch, in
Verron silk.
Sonic blast of color
(this page, below) breaking
in brilliant plumes. Pajames by
Tiffeau and Busch, in Onondaga silk.
Sandor Goldberger earrings.

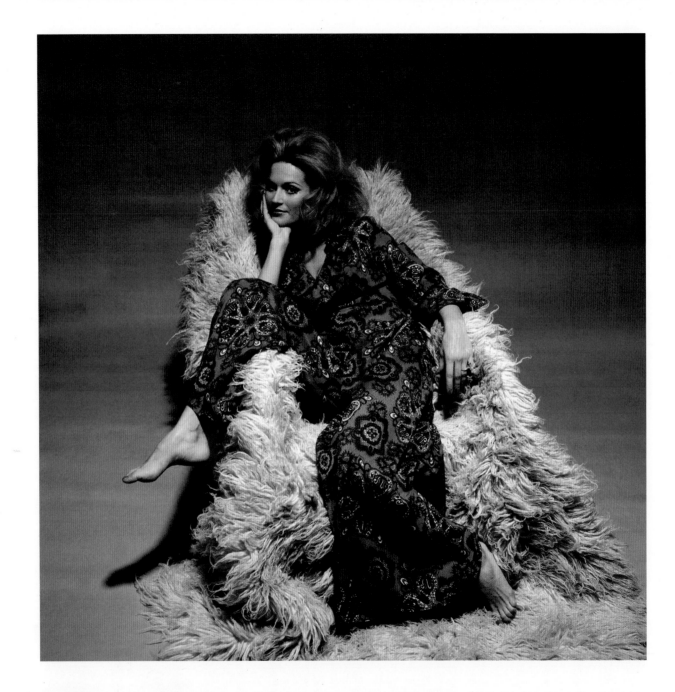

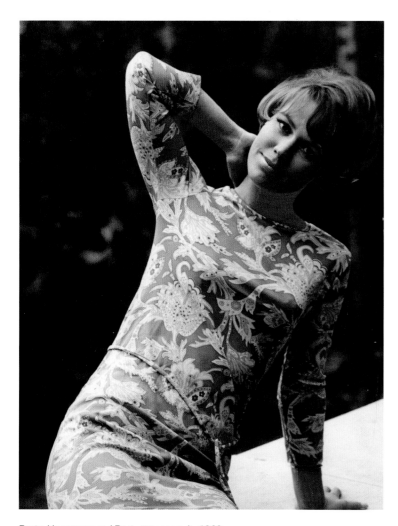

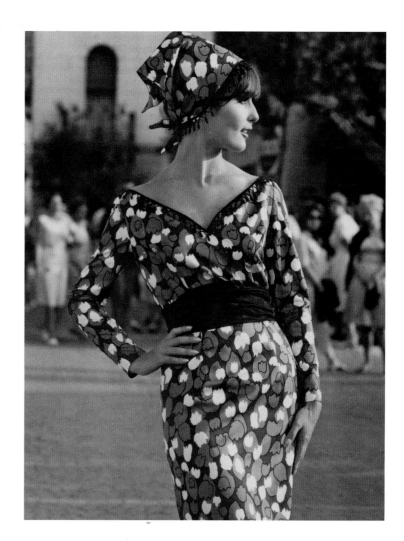

Party-Hosenanzug / Party trouser suit, 1969
Modell: unbekannt / Design: unknown

Kleid aus Seidentrikot / Silk-tricot dress, 1966
Jeanne Lanvin, Paris

Tageskleid / Dress, 1964
Modell: unbekannt / Design: unknown

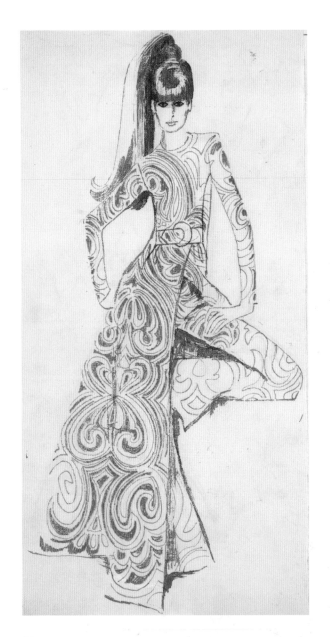

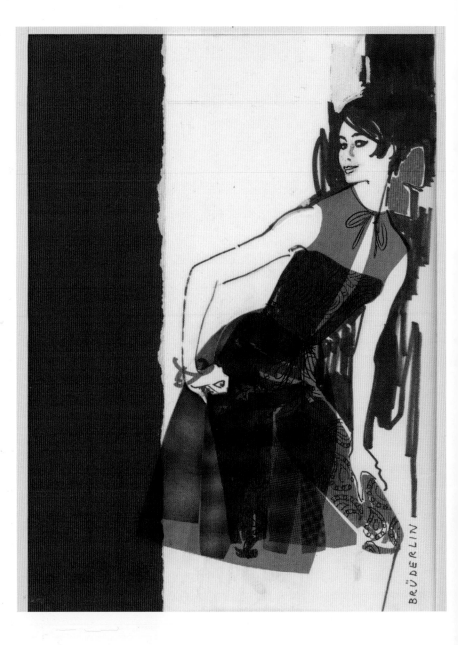

BRÜDERLIN

Gemustertes Abendensemble / Patterned
evening ensemble, 1969
Evelyn Kleider, Berlin

Ensemble mit Caprihose / Ensemble with
capri pants, 1969. Evelyn Kleider, Berlin

Hemdkleid aus Jersey / Jersey shirt dress,
1966. Lürman & Co., Rottach-Egern

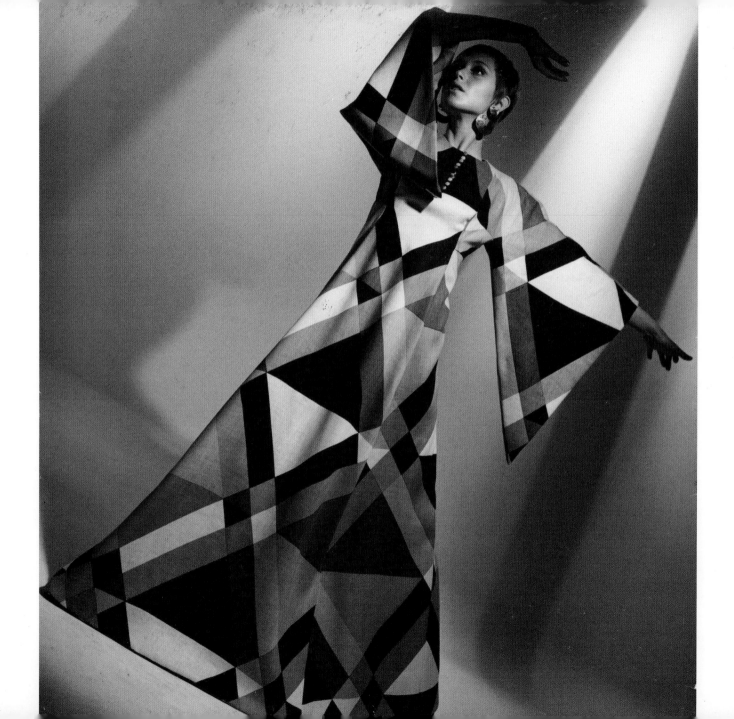

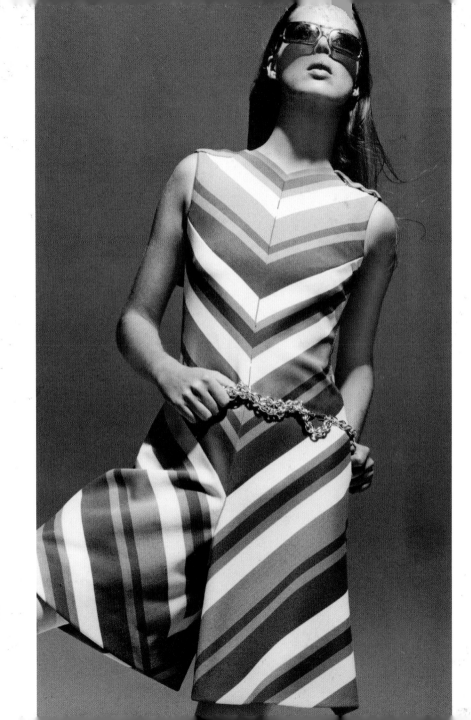

Strandkleid aus Leinen / Linen beach
dress, 1967
De Parisini, Santa Margherita

Hosenkleid aus Trevirajersey / Trevira-
jersey trouser dress, 1968
Modell: unbekannt / Design: unknown

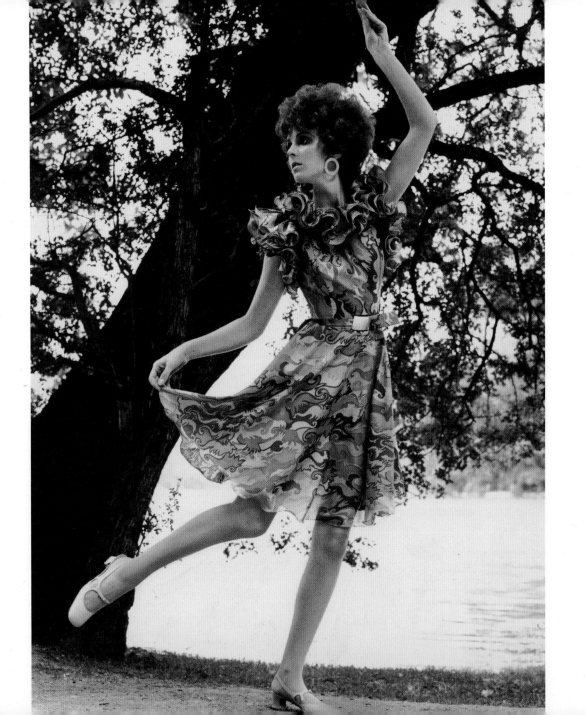

Sommerkleid aus Diolen-Georgette /
Diolen-georgette summer dress, 1967
Lürman & Co., Rottach-Egern

Cocktailkleid aus Seide / Silk cocktail
dress, 1968. Heinz Oestergaard, Berlin

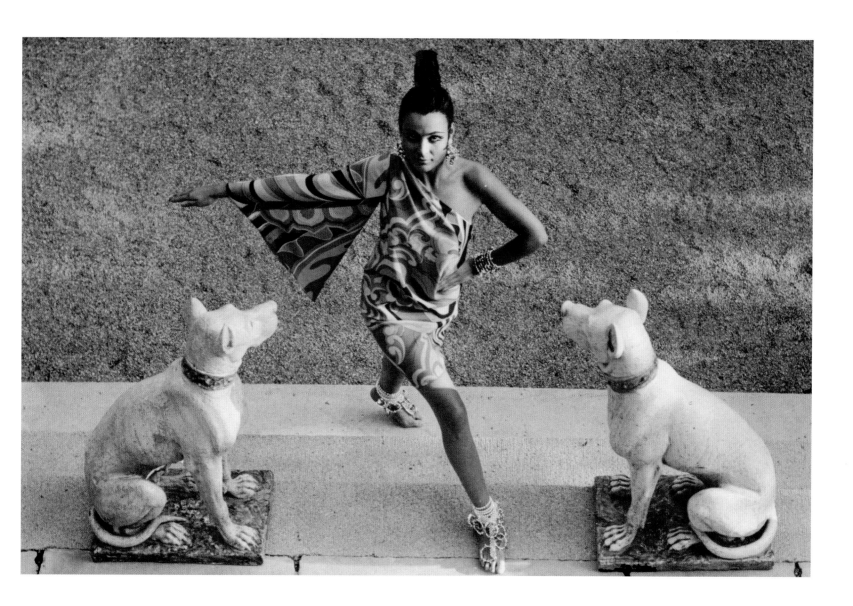

Männermode

1960 setzte der Pariser Modeschöpfer Pierre Cardin mit seiner ersten Herrenkollektion ein progressives Zeichen, das die Mode der folgenden Jahre stark prägen sollte: Die Sakkos waren kragenlos oder mit Stehkragen, die Schultern ungepolstert, die Ärmel mit kleinem Schlitz versehen. Damit wurde der formelle Anzug modernisiert und für jüngere Männer zugänglich. Einzelne Elemente dieses „futuristischen Space-Looks" – darunter Reißverschlüsse und asymmetrische Revers – nahm die internationale Modeindustrie nach und nach auf.

Ab etwa 1965 konnten modebewusste Männer zwischen verschiedenen Stilen wählen. Neben dem klassischen dreiteiligen Anzug und den modernen Anzügen im Cardin-Stil waren Ensembles aus Sakko und Hose im Angebot, zu Breitcordhosen wurden bunt gemusterte Hemden oder Pullover getragen, auch Jeans in Kombination mit Polohemden waren beliebt. Breite Krawatten mit bunten Mustern boten einen modischen Blickfang. Verbindende Elemente aller Stile waren einerseits die starke Körperbetonung, andererseits die neuen pflegeleichten und knitterarmen Synthetikstoffe.

Vorbilder für die Jugend waren so unterschiedliche Musikstars wie die Beatles, Rdie olling Stones, Bob Dylan, Santana oder Jimi Hendrix, aber auch Filmfiguren wie James Bond oder Doktor Schiwago. Sie standen für verschiedene Lebensentwürfe und Moderichtungen: vom knappen Anzug der Mods mit Pilzkopffrisur über strenge Outfits mit Metallgürtel hin zu den Hippies mit ethnischer Kleidung, selbst gemachten Accessoires und schulterlangen Lockenköpfen. In den späten Sechzigern zeigten sich die Männer so modisch wie lange nicht mehr, Soziologen sprachen von der „Peacock Revolution" (Pfauen-Revolution). Die Geschlechtergrenzen verschwammen, Männer wurden als weich und romantisch charakterisiert. Sie trugen Rüschen und Spitzen, auffallend gemusterte Hemden, weit ausgestellte Hosen und eng anliegende Oberteile. Erstmalig wurde nun Männerkosmetik beworben, mehrere Modezeitschriften für Männer kamen auf den Markt. AR

Men's Fashions

In 1960, Parisian fashion designer Pierre Cardin took a bold step with his first men's collection that went on to define the following years: sports jackets were either collarless or had stand-up collars, the shoulders were unpadded and a small slit ran along the sleeves. This modern take on the formal suit made it accessible to younger men. Individual elements of this 'futuristic space look' (including zips and asymmetric lapels) were gradually taken up by the international fashion industry.

From around 1965, fashion conscious men had several different styles to choose from. Besides the classic three-piece suit and modern suits in the style of Pierre Cardin, there were also ensembles comprising sports jacket and trousers, while thick corduroy trousers were worn with colorful printed shirts or pullovers and the combination of jeans and polo shirt was even popular. Wide ties with colorful patterns became the eye-catching feature in outfits. Unifying elements of all styles were on the one hand close-fitting cuts that hugged the body at least in part, and on the other, the new synthetic fabrics that were easy to wash and relatively crease-free.

Role models for the young were such diverse stars as The Beatles, The Rolling Stones, Bob Dylan, Santana or Jimi Hendrix, as well as film figures such as James Bond or Doctor Zhivago. They stood for various different lifestyles and fashions: from the tight suit of the mods with 'moptop' haircuts, to severe outfits with metal belts, to the hippies with their ethnic clothing, self-made accessories and shoulder-length curly hair. In the late Sixties, men were keen to be seen as fashionable in a way barely seen before and sociologists spoke of the 'Peacock Revolution'. The boundaries between the sexes became blurred, men were characterized as soft and romantic. They wore frills and lace, shirts with striking prints, flared trousers and tight-fitting tops. Cosmetics for men went on sale for the first time and several fashion magazines for men hit the market. AR

Arbiter Milano 1964, Nr. / No. 249

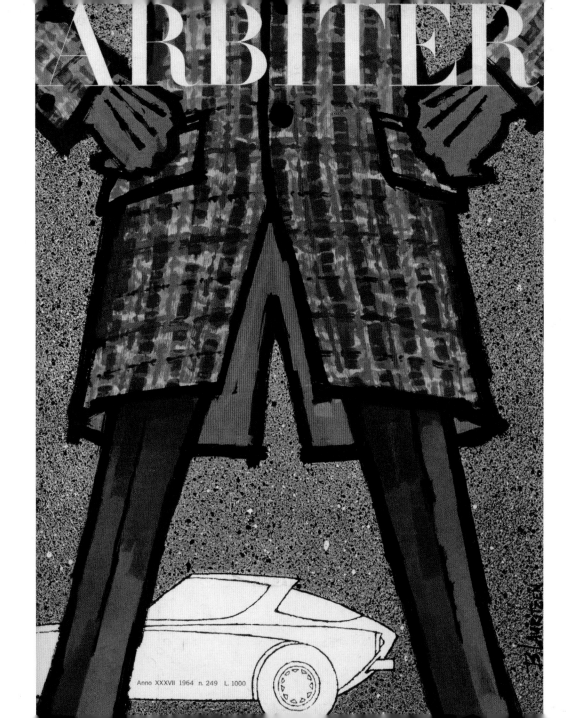

ARBITER

Anno XXXVII 1964 n. 249 L. 1000

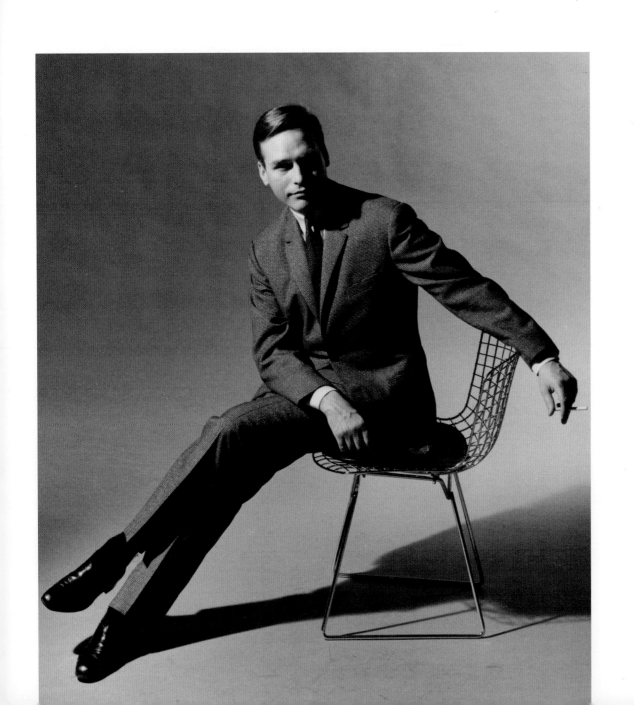

Anzug aus Hahnentritt-Tergal / Hounds-
tooth Tergal suit, 1962/64. Arya, Paris

Freizeithemden aus Baumwollgewebe /
Casual cotton weave shirts, 1968
Kennmore, Borne (Holland)

Heller Sommeranzug aus Leinen / Light
linen summer suit, 1966
Angelo Litrico, Rom / Rome

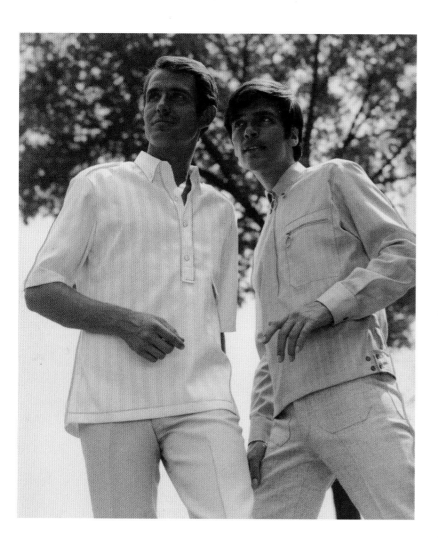

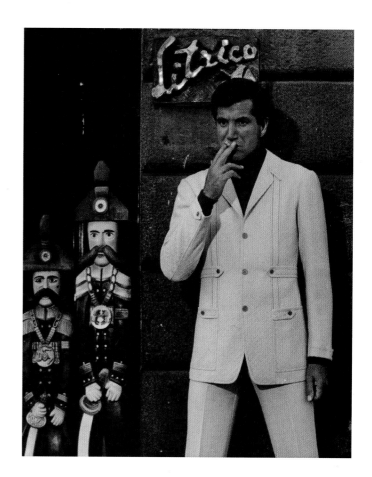

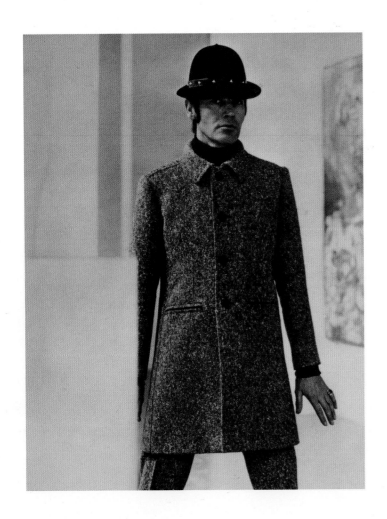

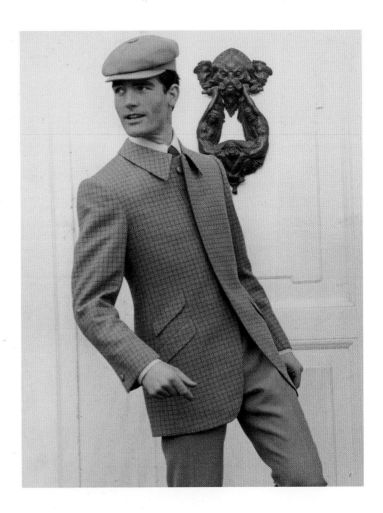

Dreiteiliges Ensemble aus Tweed / Three-piece tweed ensemble, 1968. Tom Gilbey, London

Graubraune Jacke aus Kammgarn / Grey-brown worsted jacket, 1968 Heinz Oestergaard, Berlin

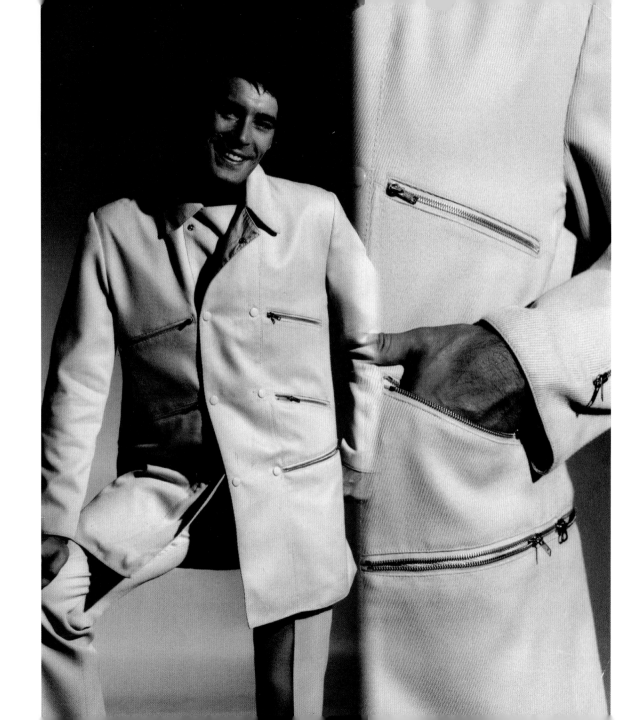

Anzug mit Cabanjacke / Suit with
Caban jacket, 1968
Bernard des Quatrepingles, Paris

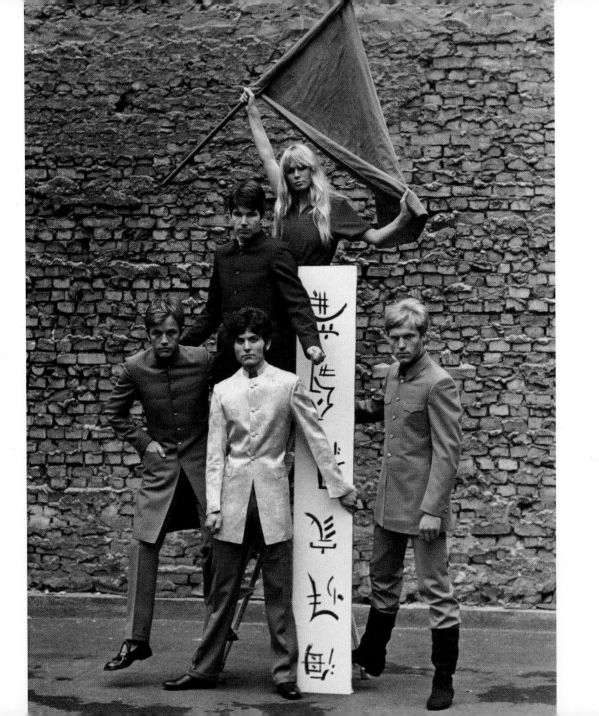

Asiatisch inspirierte Anzüge / Suits
inspired by the Far East, 1967
Norbert's Boutique, Berlin

Dunkelgrünes Hausgewand aus
Samt / Dark-green velvet house
robe, 1969. Blades, London

Smokinghemd mit Stickerei / Dress
shirt with embroidery, 1969
Nicoline, Hemsbach

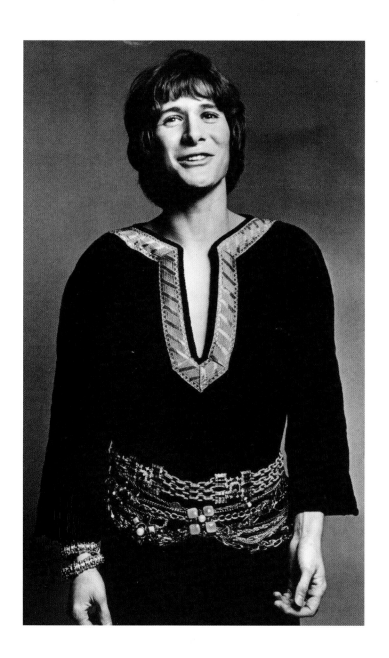

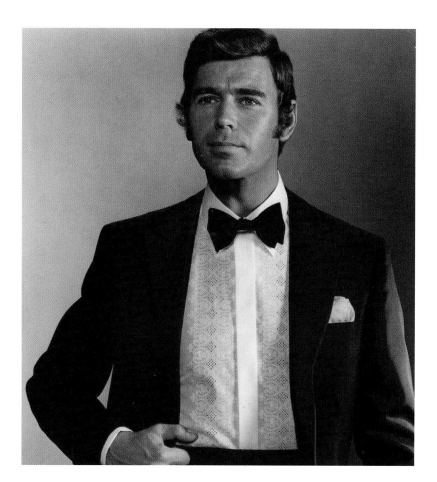

Swinging Party: Festliche Nächte

Ähnlich wie in den 1920er Jahren war der Kontrast zwischen der Tages- und Abendkleidung in den Sechzigern auffällig: „Je sachlicher und nüchterner eine Zeit ist, desto märchenhafter werden ihre Träume", überschrieb die Zeitschrift *Constanze* im Winter 1963/64 einen Bericht zu den neuesten Abend- und Ballkleidern der Saison. Für die formellen Abendanlässe – großes Dinner, Ball und Theater – zeigten die Modehäuser lange, eher schmal geschnittene Roben mit reicher Stickerei oder mit Spitzenbesatz, die mit Stolen und kostbaren Pelzen kombiniert werden konnten. 1966 boten vor allem Cardin und Lanvin moderne geometrische Details an, Dior und Ricci setzten dagegen auf die Wirkung luxuriöser Seidenstoffe in klarer Schnittführung mit üppig verzierten Oberteilen.

Für die vielen jungen Kundinnen, die den konventionellen Abendensembles wenig abgewinnen konnten, entstand nun eine eklektische Vielzahl von Outfits, die auf Partys und in der Disco, im Nachtclub und in der Bar getragen wurden. Stilistisch von der Romantik zum Space-Look reichend, boten alle Modelle viel Bewegungsfreiheit: kniekurze Babydolls aus transparentem Chiffon, legere Partykleider aus Wolljersey, weit schwingende Tanzkleider aus schimmernden Lurexgeweben, paillettenbestickte Hängerkleider im Stil der 1920er Jahre, lange Kamin- und Terrassenkleider aus pflegeleichten Synthetikgeweben, romantische Partyanzüge mit rockweiten Hosen, sogenannte Palazzo-Pyjamas (erstmalig von Irene Galitzine in Rom zu Beginn der Sechziger angeboten) und folkloristische Kaftane zu schmalen langen Röcken oder weiten Hosen. Bevorzugte Farben der Abendmode waren Schwarz, Weiß oder metallisch Glänzendes, dazu kamen farbige Kleider in Rosa, Lila oder Blau. AR

Swinging Party: Festive Occasions

As in the 1920s, the contrast between day wear and evening wear was striking in the Sixties: 'The more rational and sober an age is, the more fairytale-like its dreams become,' declared the magazine *Constanze* in winter 1963/64 in a report on the season's latest evening dresses and ball gowns. For the formal evening event – banquettes, balls and the theatre – the fashion houses presented long gowns that tended to be tightly fitting, adorned with rich embroidery or lace trimming, which could be combined with stoles and luxurious furs. In 1966, the collections of Cardin and Lanvin in particular were conspicuous for their rich modern geometric details, Dior and Ricci, by contrast, went in for the effect of luxurious silk fabrics in clear cuts with lavishly adorned tops.

For many of the young customers who were not completely taken with the idea of the conventional evening ensemble, an eclectic variety of outfits were created that could be worn to parties and in discotheques, in nightclubs and in bars. Ranging in styles from the romantic look to the futuristic space look, all models offered their wearers great ease of movement: knee-length baby dolls made out of see-through chiffon, casual wool jersey party dresses, voluminous dance dresses made from shimmering Lurex fibres, sequin-draped sack dresses in the style of the 1920s, long hostess gowns made out of easy-to-clean synthetic fibres, romantic party suits with wide legged trousers the width of skirts, 'palazzo pyjamas' (first designed by Irene Galitzine in Rome at the beginning of the Sixties) and folkloric kaftans to tight, long skirts or wide trousers. Preferred colors for evening dress were black, white or metallic sheen, accompanied by colorful dresses in pink, purple or blue. AR

Cocktailkleid mit Perlenstickerei /
Beaded cocktail dress, 1967
Staebe-Seger, Berlin

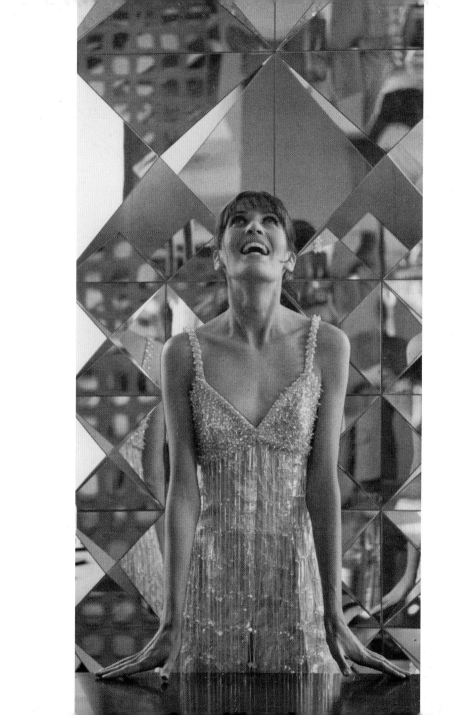

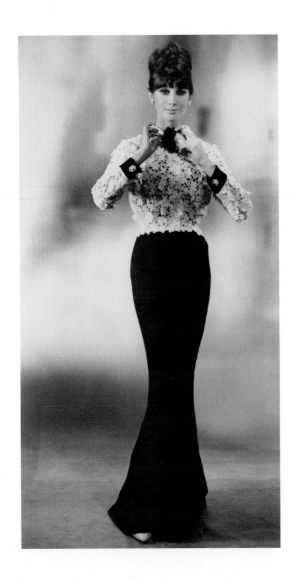

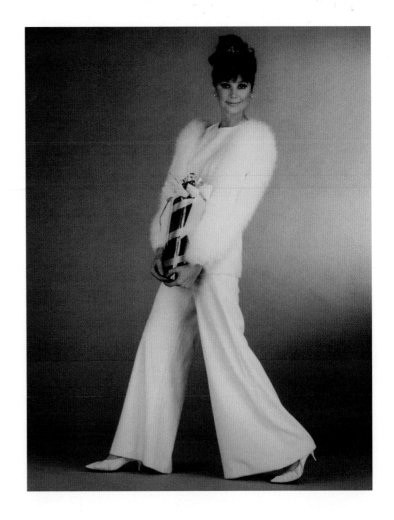

Abendkleid mit Spitzenjäckchen / Evening dress with lace jacket, 1965. Uli Richter, Berlin

Ensemble aus Jersey und Weißfuchs / Jersey and white fox fur ensemble, 1965 Léonard, Paris

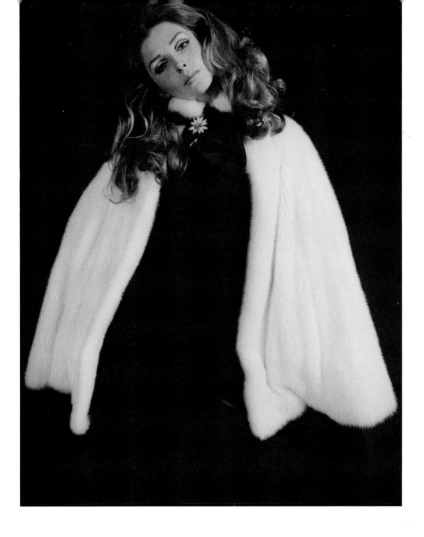

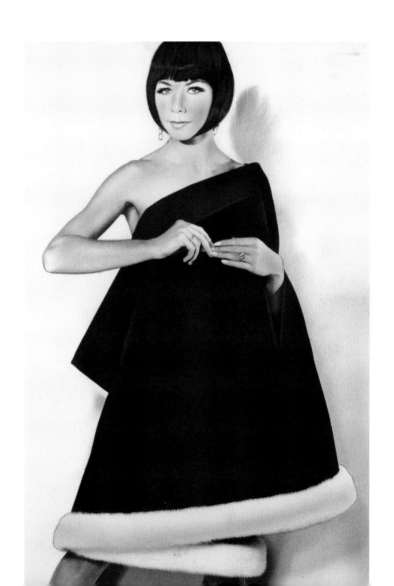

Nerzcape zum Smokinganzug / Mink cape
and dinner suit, 1967. Chombert, Paris

Abendkleid aus Seidengaze mit Nerzbesatz /
Tiffany evening dress with mink trim, 1966
Detlev Albers, Berlin

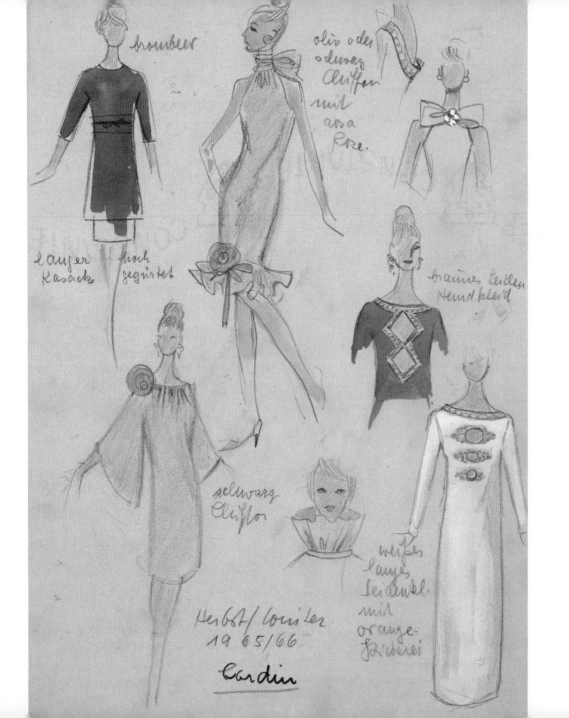

Kollektionsübersicht / Collection overview, 1965/66. Pierre Cardin, Paris

Abendkleid aus Diolen-Georgette / Diolen-georgette evening dress, 1966
Lürman & Co., Rottach-Egern

Abendkleid aus Wolljersey / Wool-jersey evening dress, 1966
Lauer-Böhlendorff, Krefeld

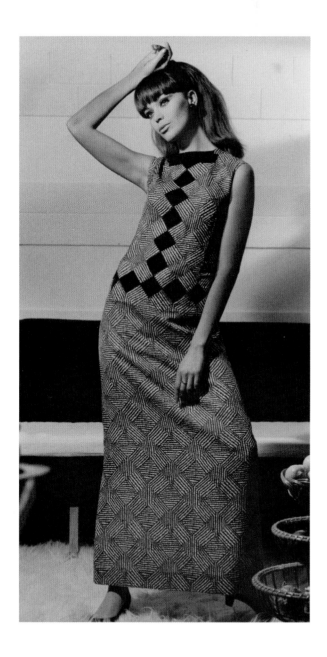
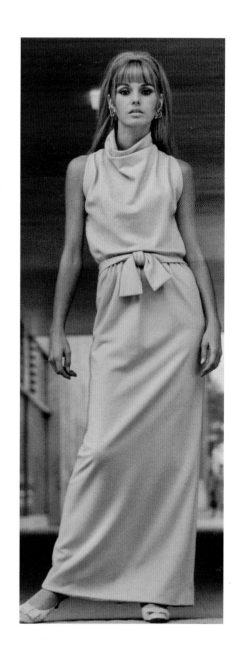

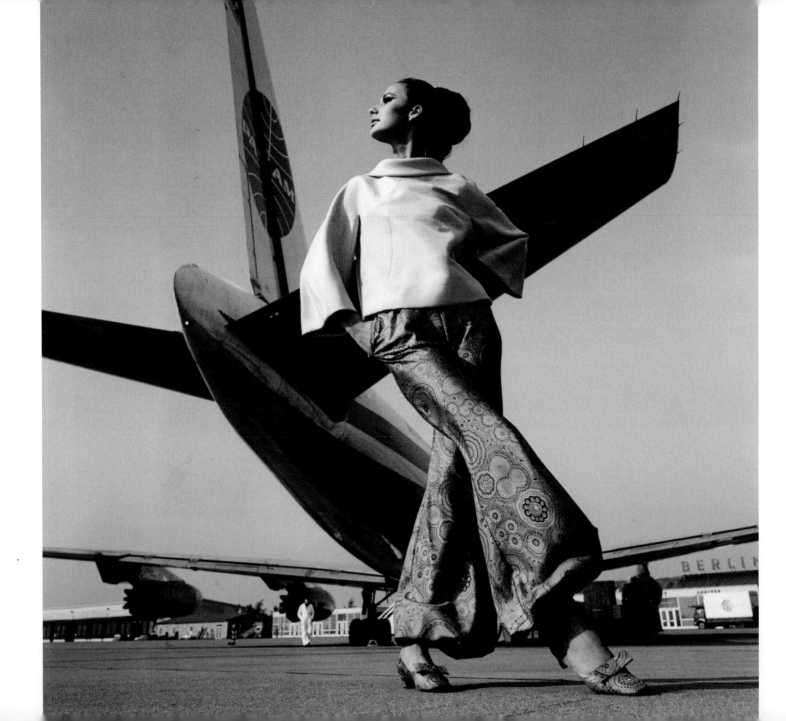

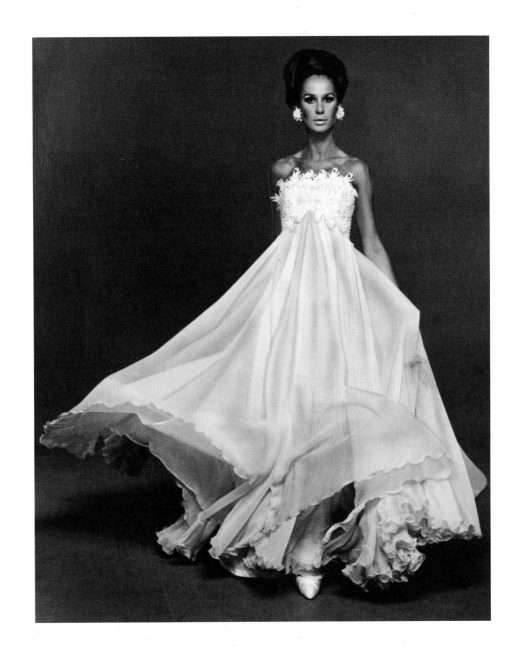

Abendensemble / Evening ensemble,
1966. Uli Richter, Berlin

Abendkleid aus Chiffon mit Spitze /
Chiffon evening dress with lace, 1966
Heinz Oestergaard, Berlin

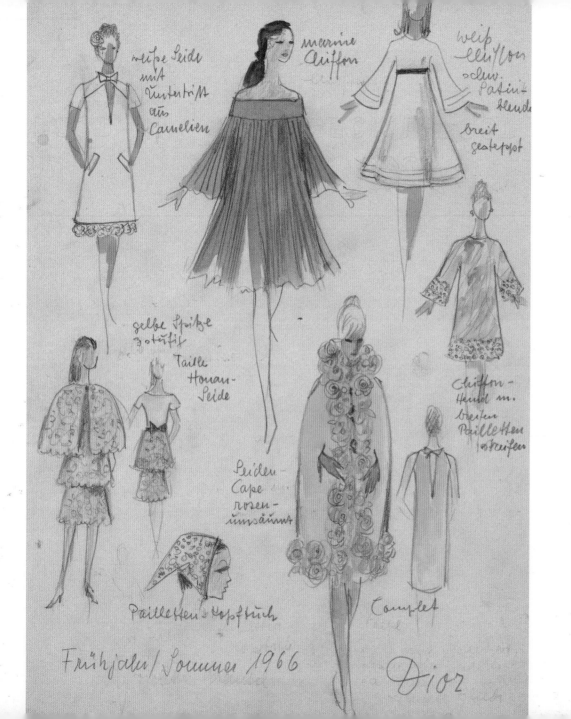

weiße Seide
mit
Untertritt
aus
Camelien

marine
Chiffon

weiß
Chiffon
oder
Pasin-
Hemde

breit
gesteppst

gelbe Spitze
3-stufig

Taille
Honan-
Seide

Chiffon-
Hemd m.
breiten
Pailletten
streifen

Seiden-
Cape
rosen-
umsäumt

Pailletten-Kopftuch

Complet

Frühjahr/Sommer 1966

Dior

Kollektionsübersicht / Collection over-
view, 1966. Christian Dior, Paris

„Party-Hängerchen" aus Shantung /
Shantung party tunic, 1968
Gerhard Ebel, Berlin

Paillettenkleid / Sequin dress,
um / around 1965
Modell: unbekannt / Design: unknown

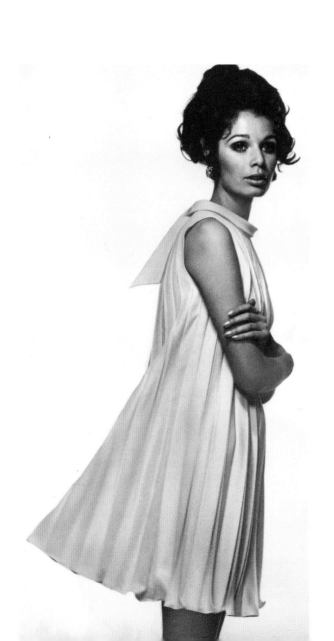

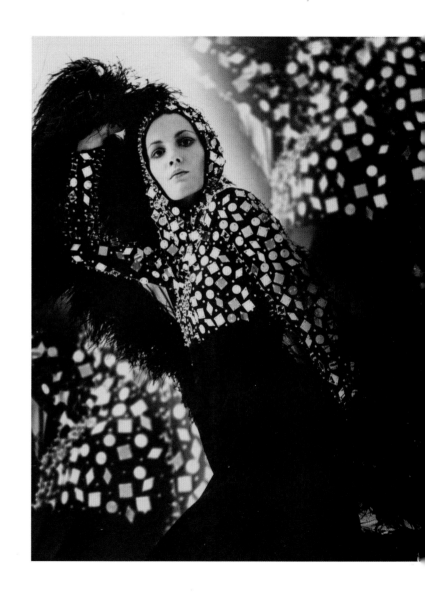

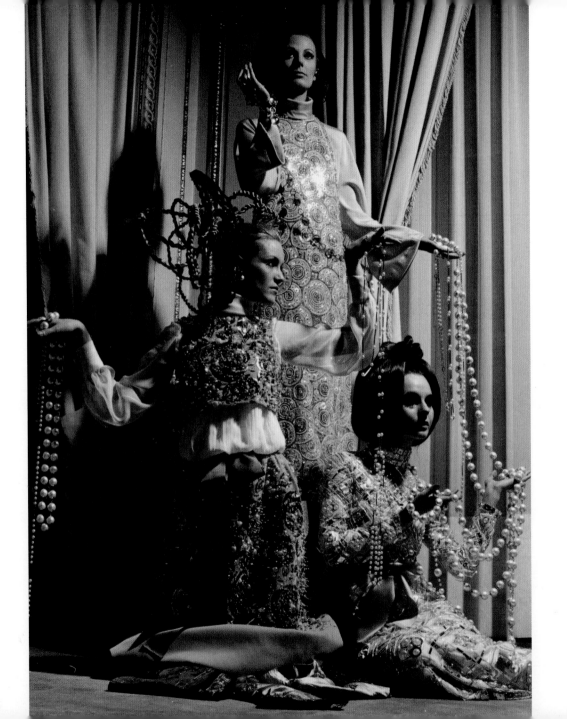

Abendkleider / Evening dresses, 1969
Jean Patou Haute Couture, Paris

Abendkleid aus Satin mit Pailletten /
Satin evening dress with sequins, 1967
Jeanne Lanvin, Paris

Abendensemble / Evening ensemble,
1965. Trevira-Studio, Hattersheim

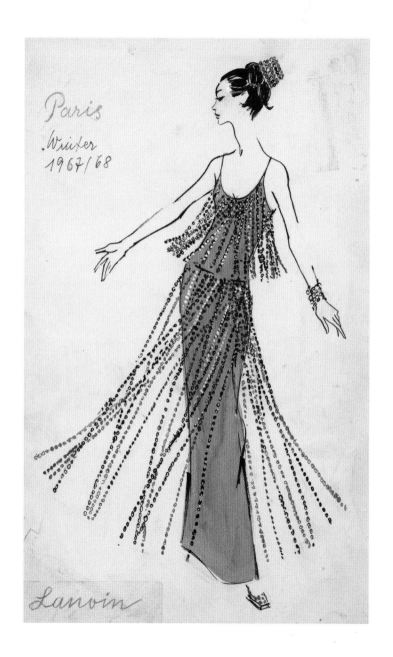

Paris
Winter
1967/68

Lanvin

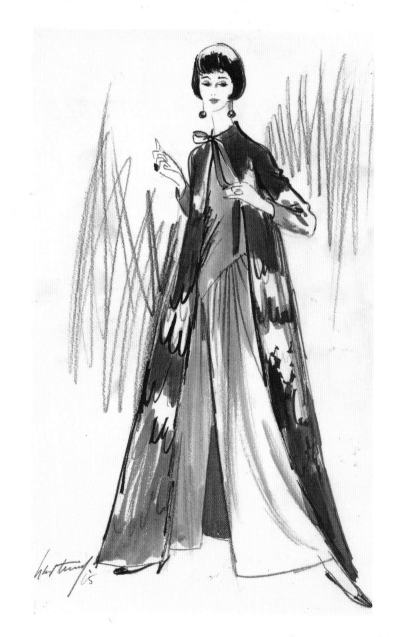

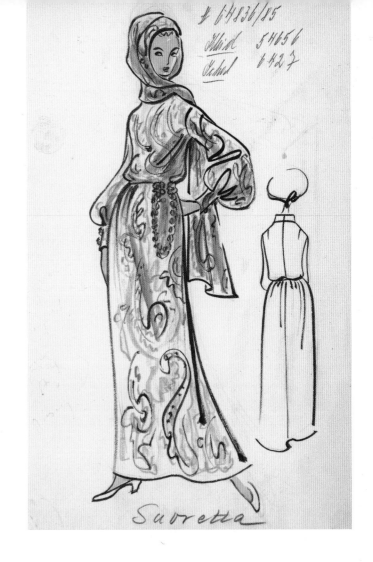

Entwürfe für Abendkleider / Designs for
evening dresses, 1969. Uli Richter, Berlin

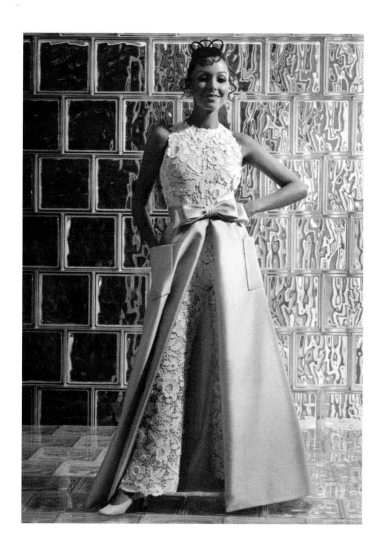

Hosenensemble mit Überrock / Trouser
ensemble with skirt, 1969. Uli Richter, Berlin

Partyanzug / Party suit, 1965
Uli Richter, Berlin

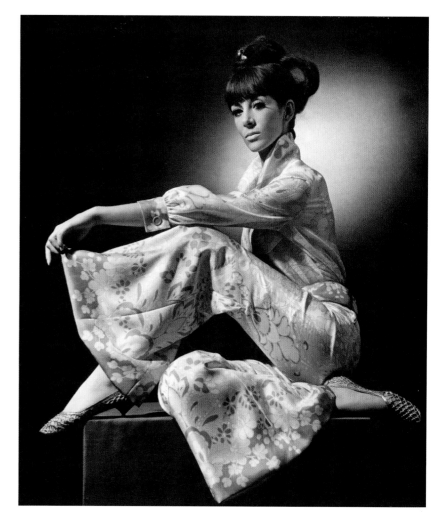

Bildnachweis / Photo Credits

Alle Abbildungen zeigen Objekte aus der Sammlung Modebild - Lipperheidesche Kostümbibliothek, Kunstbibliothek Staatliche Museen zu Berlin. Die S. 6, 45 und 73 zeigen Fotografien der Dauerleihgabe der Helmut Newton Foundation, Kunstbibliothek, Staatliche Museen zu Berlin.

All illustrations are of objects from the Sammlung Modebild - Lipperheidesche Kostümbibliothek, Kunstbibliothek Staatliche Museen zu Berlin. The photographs on pages 6, 45 and 73 are part of a permanent loan from the Helmut Newton Estate, Kunstbibliothek, Staatliche Museen zu Berlin.

Wir danken allen Inhabern von Bildnutzungsrechten für die freundliche Genehmigung der Veröffentlichung. Sollte trotz intensiver Recherche ein Rechteinhaber nicht berücksichtigt worden sein, so werden berechtigte Ansprüche im Rahmen der üblichen Vereinbarungen abgegolten.

We thank all copyright owners for their kind permission to reproduce their material. Should, despite our intensive research any person entitled to rights have been overlooked, legitimate claims shall be compensated within the usual provisions.

Bildnachweis / Photo Credits

Cover: Sportkleid und Jersey-Overall / Sports dress and jersey overall, 1967 Pierre Cardin Haute Couture, Paris

2: Wollkostüm / Wool suit, 1962 Modell: unbekannt / Design: unknown

4: Helmhut aus Wollstoff / Wool helmet hat,1965. Jacques Heim, Paris

6: Pelzmantel aus Waschbär / Coat of natural racoon, 1967. Wallis Shop, London

8: Carnaby Street by Tom Salter, Walton on Thames, 1970

10: Kostüm mit Waschbärkragen / Suit with racoon fur collar, 1967 Danzl, Berlin

124: Modische Party / Fashionable party, um / around 1969

Verwendete Literatur / Selected References

Angelogou, Maggie: A history of Make-up. London 1970

Baudot, François; Demachy, Jean: Style Elle, nos années 60. Paris 2002

Breward, Christopher; Gilbert, David; Lister, Jenny: Swinging Sixties – Fashion in London and beyond 1955-1970. London 2006

Buck, Susanne: Gewirkte Wunder, hauchzarte Träume: Von Frauenbeinen und Perlonstrümpfen. Marburg 1996

Corson, Richard: Fashions in Makeup. London 1972

Felderer, Brigitte: Gernreich, Rudi – Fashion will go out of fashion. Köln 2000

Fogg, Marnie: Boutique – a '60s cultural phenomenon. London 2003

Guillaume, Valérie: Magier der Mode - Courrèges. München 1998

Janecke, Christian (Hg. / Ed.): Haar tragen – Eine kulturwissenschaftliche Annäherung. Köln 2004

Jenß, Heike: Sixties Dress Only. Mode und Konsum in der Retro-Szene der Mods. Frankfurt a. Main 2007

Kamitsis, Lydia: Paco Rabanne. Paris 1996

Längle, Elisabeth: Pierre Cardin. Wien 2005

Loschek, Ingrid: Fashion of the century – Chronik der Mode von 1900 bis heute. München 2001

Marwick, Arthur: The Sixties. Cultural Revolution in Britain, France, Italy and the United States, c.1958-c.1974. Oxford 1998

McCracken, Grant: Big hair – A journey into the transformation of self. London 1997

Schepers, Wolfgang: '68. Design und Alltagskultur zwischen Konsum und Konflikt. Köln 1998

Sixties – Mode d'emploi. Collections du Musée de la Mode et du Textile. Paris 2002

Tolkien, Tracy: Vintage – The art of dressing up. London 2000

Turner, Alwyn W.: Biba – the Biba experience. London 2004

Veillon, Dominique u. M. Ruffat (Hg. / Ed.): La mode des sixties. L'entrée dans la modernité. Paris 2007

Impressum / Colophon

Diese Publikation erscheint anlässlich der Ausstellung
„High Sixties Fashion: Modefotografie und –illustration" /
This book is published on the occasion of the exhibition
"High Sixties Fashion: Fashion Photography and Illustration"
Kunstbibliothek, Staatliche Museen zu Berlin
Kulturforum Potsdamer Platz, 8. April bis / to 1. August 2010
www.smb.museum

© 2010 Staatliche Museen zu Berlin – Stiftung Preußischer Kulturbe-
sitz, die Autoren / the authors und / and Verlag der Buchhandlung
Walther König, Köln
© VG Bild-Kunst, Bonn 2010 für / for Henry Clarke and Karin Kraus

**Projektleitung, Ausstellungs- und Katalogkonzeption / General
Editor, Exhibition and Catalog Curator:** Adelheid Rasche
Grafische Gestaltung / Graphic Design: André Korbmacher
Texte / Texts: Adelheid Rasche (AR) und / and Hildegard Ringena (HR)
Mitarbeit / Editorial Assistance: Daniela Kratz
Übersetzungen / Translations: Christina Thomson
Verlagslektorat / Copyediting: Tom Ashford, Patricia Blankenhagen,
Joachim Geil
Reproduktionen / Reproductions: Kunstbibliothek, Staatliche
Museen zu Berlin, Hajo Raschke
Gesamtherstellung / Production: Printmanagement Plitt,
Oberhausen

Erschienen im / Published by
Verlag der Buchhandlung Walther König, Köln
Ehrenstr. 4, 50672 Köln
Tel. +49 (0) 221 / 20 59 6-53
Fax +49 (0) 221 / 20 59 6-60
verlag@buchhandlung-walther-koenig.de

Bibliografische Information der Deutschen Nationalbibliothek
Die Deutsche Nationalbibliothek verzeichnet diese Publikation in der
Deutschen Nationalbibliografie; detaillierte bibliografische Daten sind
über http://dnb.d-nb.de abrufbar.

Printed in Italy

Vertrieb / Distribution:

Schweiz / Switzerland
Buch 2000
c/o AVA Verlagsauslieferungen AG
Centralweg 16
CH-8910 Affoltern a.A.
Tel. +41 (44) 762 42 00
Fax +41 (44) 762 42 10
a.koll@ava.ch

UK & Eire
Cornerhouse Publications
70 Oxford Street
GB-Manchester M1 5NH
Fon +44 (0) 161 200 15 03
Fax +44 (0) 161 200 15 04
publications@cornerhouse.org

Außerhalb Europas / Outside Europe
D.A.P. / Distributed Art Publishers, Inc.
155 6th Avenue, 2nd Floor
USA-New York, NY 10013
Fon +1 212 627 1999
Fax +1 212 627 9484
www.artbook.com

ISBN 978-3-86560-798-0

**Die Autorinnen danken für vielfältige Hilfe /
The authors wish to thank for assistance:**
Dagmar Berndt
Martin Gosewisch
Hans-Jürgen Kammer
Daniela Kratz
Christiane Schmidt